Contents

Chapter 1:
HDR Setup

Before we go into the field, it's critical that you know how to set up your camera for HDR shots. I am going to show you on a Canon 70 which is basically the same as the 5D Mark II, 5D Mark III, 6D, etc. It's the same philosophy between all of these Canons, and I am going to show you on the Sony as well because these are the two main cameras I am using. Once you understand how to set up for HDR with these two, you will understand how to do it with any camera.

There are three primary details to keep in mind as we proceed: First, the ideal scene of shooting HDR is to be on a *tripod,* so we can be sure that all 3 photos are aligned. The second thing I would recommend is to shoot *Manual.* Finally, we want to ensure that we're capturing scenes that are properly *Exposed.* Let's proceed.

Canon

WHAT IS EXPOSURE?

In photography, Exposure is the amount of light per unit area (the image plane illuminance times the exposure time) reaching a photographic film or electronic image sensor, as determined by shutter speed, lens aperture and scene luminance.

Generally, we know that we're going to be missing details in the highlights and the shadows of our scene; we're getting a bit of an average. The *Automatic Exposure Bracketing* feature is going to take care of the rest-- it's going to do the lower exposure, the higher exposure. Make sure that we're set up on Manual and that we're on an average exposure. Let's have a look at how to do this on the Canon:

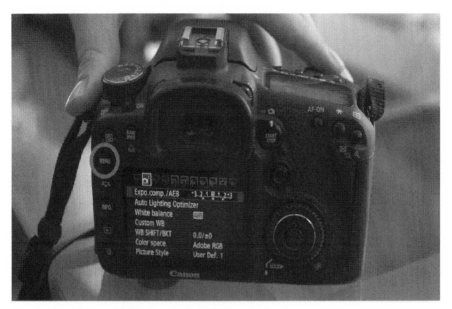

After we turn on the camera, we go into the Menu.

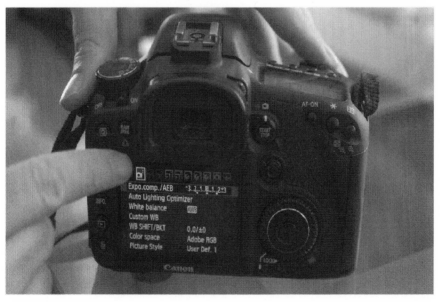

We need to find Exposure Composition/Automatic Exposure Bracketing. In this Canon's menu, it is listed as "Expo.comp./AEB"

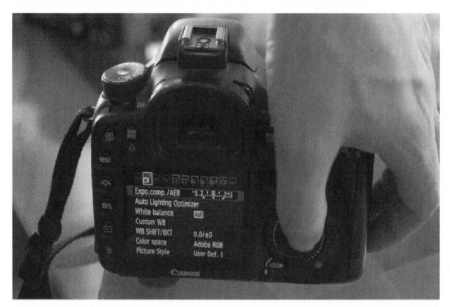

Select it with the large Setting/Movie shooting button on the Quick Control Dial.

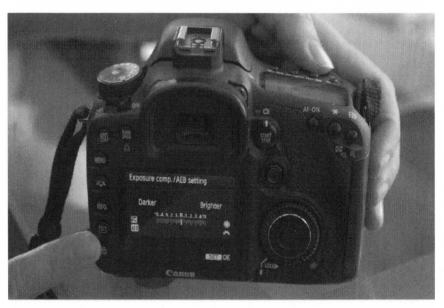

And here we have the Exposure Composition range. The line should be in the middle if you've never modified this setting.

We want to use the Main Dial (on the Canon) to set the AEB to 2—Minus 2

into Darker and positive 2 into Brighter. We can go as far as 3, but I would not recommend it as the photos in our HDR range would end up being too far apart in exposure. The dark one would be too dark, the brighter would be too over-exposed.

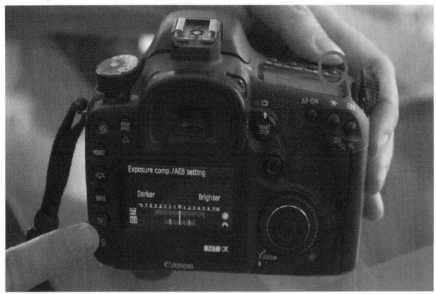

Set the Exposure Composition to 2, using the Main Dial.

Once we've made this change, we press the Setting/Movie shooting button once more and we're good to go; we've set up our Automatic Exposure Bracketing.

WHAT IS ISO SPEED?

The sensitivity of film emulsion to light is called its 'speed' and is given an ISO number. Low numbers, such as 50 or 100, indicate a relatively low sensitivity to light. Digital photography maintains the ISO speed system.

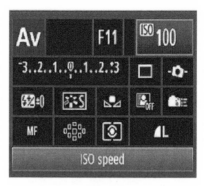

ISO100 setting on a Canon.

A Tip for ISO

We always want the lowest ISO setting possible because HDR is going to bring out noise. We'll shoot at 100 ISO on both cameras in this Master Class

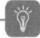

TIMER

The next thing we should do is set up a 2-second Timer. This way, when we press the Shutter, it's going to wait 2 seconds before taking 3 Exposures: exactly what we want. We'll get more detailed with this in later chapters.

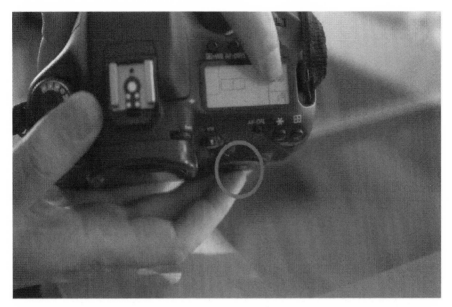

Set the Timer to 2 seconds, using the Quick Control Dial.

FOCUS

If you are not familiar with the Manual Focus of your Canon, I would advise that you use the Aperture Value mode (Av). Av sets the Shutter for all three photos. Let's consider an example: If we are at 7.1 Megapixels, our under-Exposed photo will actually be a quicker Exposure, perhaps five hundredths of a second. It's a faster exposure, there is less light coming in, we're still at 7.1. Then our normal exposure is going to be at 7.1, one hundred and fiftieth of a second. Finally, our over-exposure is going to be a longer time; it's going to be one thirtieth of a second. That's why it's good to be on a tripod, because our over-exposed photo will always have a very slow shutter speed and we might get a blurry shot if we try to read by hand.

With Av set, we can press and focus on something, press again and it is going to take three photos, 1, 2, 3 and we are good to go. We've got our HDR with the minus 2, the Normal and the plus 2. That's how we do it with Canon.

Sony

With Sony it's a bit more difficult because you need to get a remote. The Sony remote is $10 and it's really hard to do HDR without it.

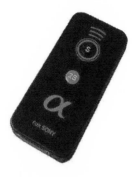

A Sony Remote

It's significant to note that the Remote is not enabled automatically by default. We should ensure that Remote Control is Always ON in the camera menu. In order to do this we select *Menu*, navigate to the last tab of the menu, and set Remote Control to *On*:

Ensure that Remote Control is On.

I would put the Sony on a tripod and basically follow the same steps as above. I would go to Manual, and do my Exposure. For the Bracketing on the Sony it's a bit different:

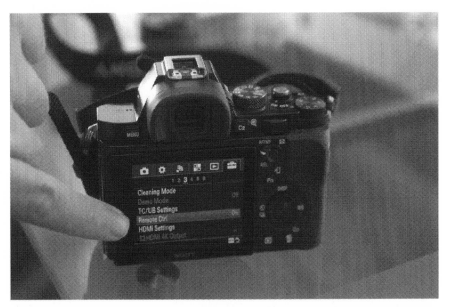

Navigate to the menu using the wheel on the rear of the camera.

Spin the wheel to navigate up/down in the in-camera menu; make changes by pressing left or right on the wheel.

Set Bracket C to 2.0EV3

We should choose the option of 2.0EV3. The 2 here indicates that the Exposure will be minus 2/ plus 2, the same setting we used for the Canon. The 3 means that the camera is going to take three photos. Finally, Bracket C means it's going to do it Continuously.

IMPORTANT NOTE ABOUT LETTERING

The Bracket S mode in the menu (versus C) will take Single shots. Meaning that if we set 2.0EV3 on Bracket S then press the remote, it's going to take one photo for the normal exposure. We press the remote a second time, and it takes one photo the under-exposure, a third press and the over-exposure photo is taken. Too much time is passing by between all 3 photos. What we want is really to be, and I insist, to be on the Bracket C option for Continuous.

Taking It Outside

Voila that's about it. Now we can go out in the field and start doing some real HDR. These are simple details, but they're good to know because we are going to have all 3 exposures and believe me, with 3 exposures we are going to get everything. I usually go either Automatic White Balance, Daylight or Shade. Shade I would only use if there is a lot of sun, and Daylight I use most

of the time. Basically, Daylight is my go-to White Balance, but you can put it in Automatic White Balance. That's about it, that's all about it. Let's go and take some photos.

Taking it outside—to Downtown Los Angeles!

For the purpose of demonstrating these camera settings, we've travelled to Downtown Los Angeles. It's getting late, we are heading into sunset. In 10 minutes the sun is going to be behind the horizon, it's going to be the end of the sunset, the beginning of the blue hour. We're facing west, where we will have light even a half an hour after sunset. I always try to shoot my HDR when there are clouds facing west, and this is proving to be a perfect spot. We've got leading lines, we're facing west, I could not dream of a better spot.

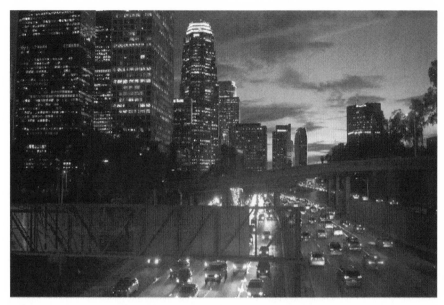

Leading Lines: Check. Facing west: Check.

We'll wait for all the lights in the skyscrapers to come on and then we are going to get some nice long exposures. It's going to be a 3-long exposure photo. I am probably going to be around a 13 and shoot: 4 seconds, 10 seconds, 15 seconds, and then we are going to mix them using the HDR software.

If we look east, the scene is already completely dark, there are no more details. Facing west, we still have a great sky. That's very important, now all we have to do is wait a little bit.

Facing east at sunset—lacking details and light.

DUTCH ANGLE

What I've tried is to do is what we call the Dutch angle, meaning you're not straight, you're going completely 45-degrees with the leading lines and the wide angle, making for a really dynamic photo. It works really well with HDR. Now we are starting to be into longer and longer exposure... On the Canon, because it's an old camera, I am going to be around F7 and I am going to be around F10 or F11 with the Sony-- I find it gives better results.

45-degree Dutch angle with the Canon

It's getting really late so it's getting into the dark hour, but I am really happy. I shot with the Canon and the Sony and I have the golden hour, I have the sunset and I have the blue hour all 3. I'm *really* happy.

Golden hour

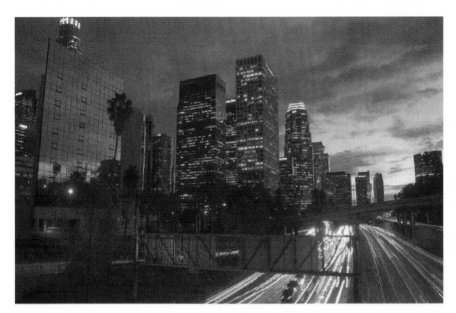

Sunset

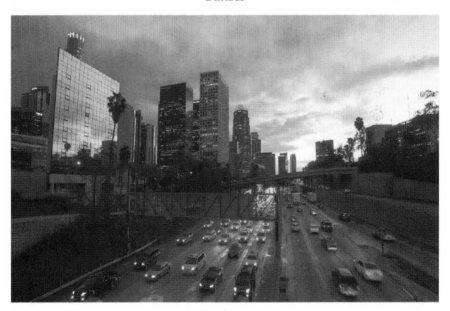

Blue hour

Let's jump over to Lightroom followed by Photomatix to see what we can do with all of this.

Chapter 2:
HDR Lightroom Preparation

All right Mesdames and Messieurs, we're back from Los Angeles where we've shot this amazing sunset in Downtown. Now I want to show you different HDR techniques that I have been using over the years. This is actually my real workflow. Usually, when I do HDR, I'm going to try different techniques and I'm just going to pick the one that works the best. Honestly, each photo has its own feeling to it and sometimes it's going to be technique A, technique B, technique C, that's going to give the best result.

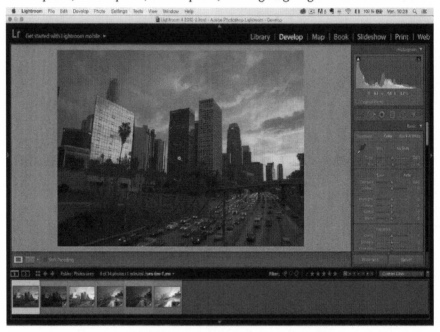

Our Downtown golden hour in Lightroom

White Balance

In my standard workflow, I will utilize Photomatix to work classic HDR techniques on the photo. We'll get into that in the next chapter. Usually, I do a little bit of fixing in Lightroom first before I go into Photomatix, especially the White Balance. You'll find that if you want to change the colors post-Lightroom, it's going to be more difficult and the end product is usually

going to be worse.

White Balance

When you shoot raw, you have to understand that the White
Balance has not been hard coded into the photo. It can be changed
as you desire. This is very important, because once you go out of the
raw file in Lightroom and begin editing in Photomatix or
Photoshop, the colors become much more set and difficult to deal
with.

Usually I will play around with the White Balance Temperature slider first, to
see what's going to give the best color. Otherwise I select Daylight from the
White Balance Presets.

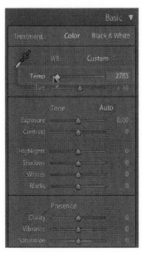

1. Play with the White Balance Temperature slider

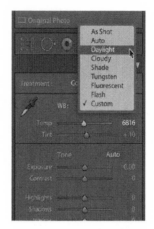

2. Select Daylight from the White Balance (WB) Presets dropdown menu

I like Daylight because on a sunset shot it gives a strong blue and some magenta. Cloudy is going to make the whole photo warmer and shade is going to make the photo even warmer.

White Balance Presets in Action

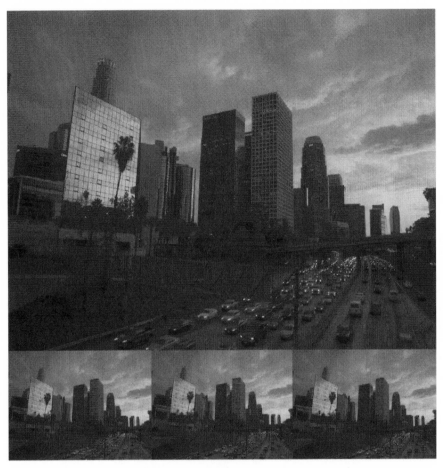

Left: Daylight / Center: Cloudy / Right: Shade

I think I'm going to go for Daylight on this one. Daylight is good because we've got a mix of blue and warm. All I do is I always add a little bit magenta, so that's kind of cool. That's the way to go.

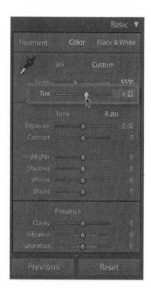

Add some Magenta using the White Balance Tint slider

Camera Calibration

If you're not happy with White Balance, you can scroll to the end of the Edit pane in Lightroom to Camera Calibration.

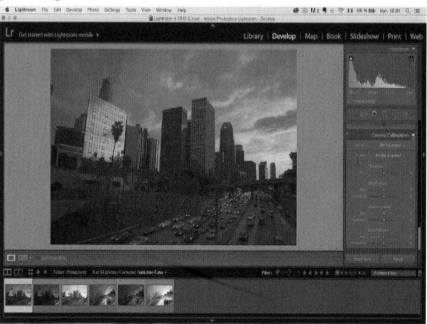

Scroll to the bottom of the Edit pane to find Camera Calibration options

WHAT IS IT?

The Camera Calibration panel offers different ways of interpreting the same settings in Lightroom. It uses two camera profiles for every camera model that it supports to process the raw images. The profiles are produced by photographing a color target under different white-balanced lighting conditions. When you set a white balance, Lightroom uses the profiles for your particular camera to extrapolate color information. You can adjust how Lightroom interprets the color from your camera by using the controls in the Camera Calibration panel and saving the changes as a preset.

In our photo's case, this was shot with Sony. The available Preset names in the dropdown list may vary from one camera to the other, so check it out thoroughly with your raw image. Let's have a look at Adobe standard versus Camera Landscape.

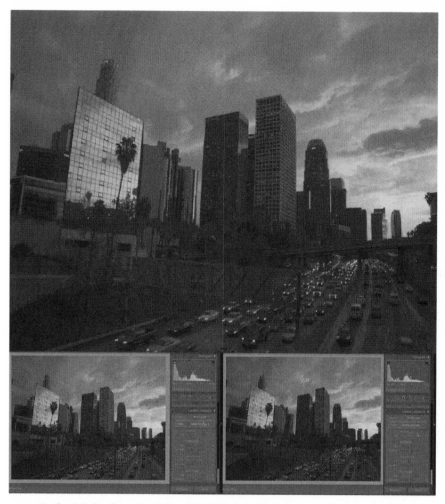

Left: Adobe Standard Profile / Right: Camera Landscape Profile

I like what Camera Landscape does, it usually makes the sunset more vivid, naturally more saturated. I love saturated colors. That's the effect we're going for.

Lens Corrections

We've taken care of the first of two major raw image steps before we move on to our HDR Engine of choice (I use Photomatix; we can use Photoshop for that purpose, but I personally hate it): Color. Now we're going to move on to Lens Corrections.

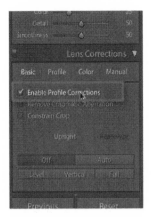

Scroll up towards the middle of the Edit pane to find Lens Corrections.

WHAT IS IT?

The Lens Corrections panel is a tool that allows fixing such lens problems as distortion, chromatic aberration, vignetting and perspective correction "non-destructively", without leaving Lightroom. Similar to how Camera Calibration is founded on the camera type, Lens Corrections are based on the type of lens used.

PROFILE CORRECTIONS

In Lens Corrections, we're going to check the box to *Enable Profile Corrections*. This is going to remove an existing wide angle effect, and some very strong *vignetting*. Vignetting means that the photo is darkened all around the corners.

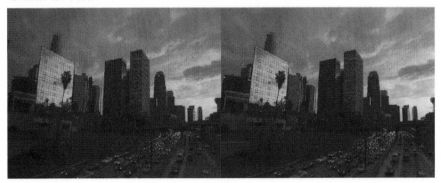

Left: No Lens Corrections / Right: Profile Corrections Enabled

Auto Alignment

Now, I usually don't select Auto alignment at this point. I have found that it creates alignment troubles, so I do it at the end. I'll show you in the workflow.

REMOVE CHROMATIC ABERRATION

One thing that's very important is selecting the option to *Remove Chromatic Aberration*. This step is very important. Chromatic aberrations are little fringes that you will find around the edges of the photo. That can really be some kind of trouble, because all these little aberrations will become amplified when we do our work in the HDR engine.

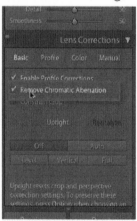

Check the box to Remove Chromatic Aberration

Detail

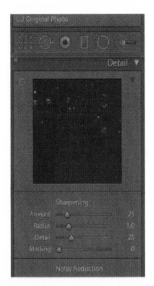

Scroll up the Edit pane to the Detail panel

The next thing that I do is to sharpen the image. Here is my technique: I look at the photo by default and if there is no visible noise, I put my Sharpening at 100. Now we've got a very sharpened photo.

1. Drag the Sharpening Amount slider to 100

At 100, I can see that it brought some noise back in. We can use the Masking slider under Sharpening to eliminate that new noise. By holding **Alt** + sliding

Masking until our sky is black, we can ensure that the Sharpening is only being applied to the white parts of the photo. It's only going to sharpen the details basically. That's kind of cool.

2. Hold Alt + drag the Masking slider until the sky is black

Wrapping Up

So on this photo, what did we do? We changed the colors with White Balance. We performed Camera Calibration and we implemented some sharpening. That's all we're going to do before going to Photomatix. Why did we do it before entering our HDR engine? Doing it before gives us better results, because we're still in the universe of raw files. This is very, very important.

SYNC

We've only performed our Lightroom edits on a single photo. What about the other photos from our Automatic Exposure Bracketing? We still need to apply all of these changes to the other photos in our bracket, and we do that by synchronizing.

We want to select all of the photos in the bracket that we want to sync our

changes to. This is made easy by right-clicking the last photo in the series on our film strip—this will select every photo between as well.

1. Right-click the last photo in your bracket series to select all

Now we click on Sync...

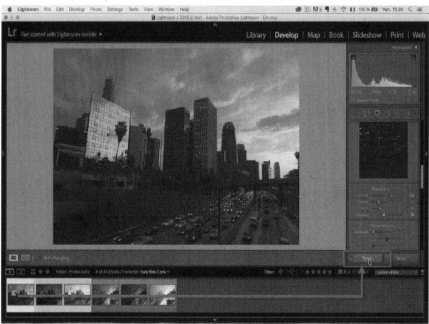

2. Click Sync...

...we click *Check All*, to ensure that all settings will be synchronized...

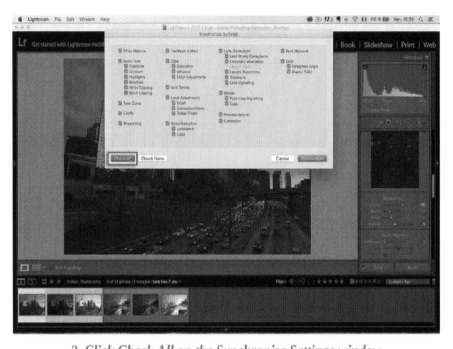

3. Click Check All on the Synchronize Settings window

...and finally, we click *Synchronize*.

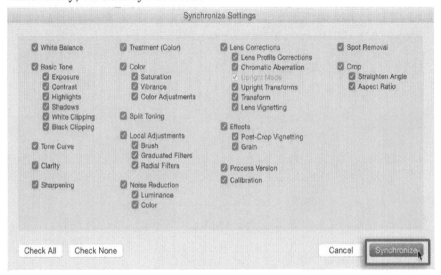

4. Click Synchronize

Now all three selected photos have the same White Balance, which is very

important.

NOISE REDUCTION

An often overlooked detail is the noise on the underexposed photo in our bracketing. Because it suffers from the greatest amount of noise, we should perform a final bit of magic after we've synched our general white balance settings.

Select only the underexposed photo from the film strip, and in the Adjustment panels on the right we want to navigate back to the Detail panel. Under the Noise Reduction sub-module, we should slide Luminance to around 30. That's my workflow. On the underexposed photo, we only use the sky and we don't want any noise on the sky.

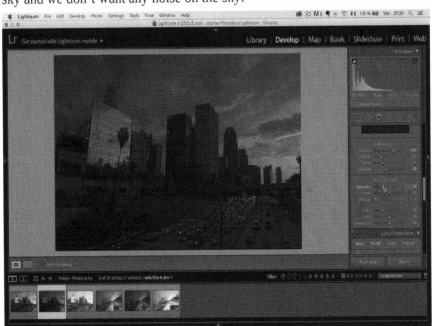

On the Detail panel, move Noise Reduction's Luminance slider to 30

EXPORT

Now, all the three photos have the same white balance, the same sharpening, and our underexposed photo has got some additional noise reduction. We're ready to go to Photomatix.

Select all three photos (with the first in the series selected, right-click on the final photo to select all) in the film strip. With all selected, **right-click** the

first photo to reveal a context menu. Hover your cursor over Export, then from the Export menu hover over Photomatix Pro. *If you have installed Photomatix, you should have the plug-in that goes with Lightroom.* Finally, we should **click** on Photomatix Pro in order to access *Settings for processing exported files.*

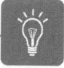

Exporting to Photomatix

With your first image selected, right-click the last photo in the series to select all

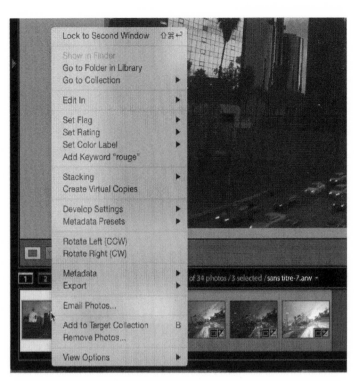

Right-click the first photo for the context menu

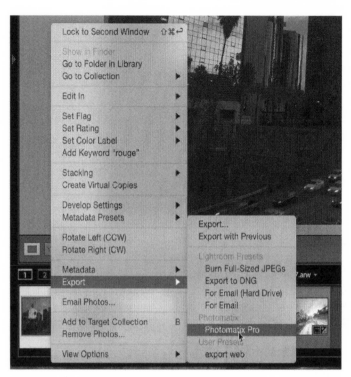

Hover over Export to open its sub-menu, then click on Photomatix Pro

SETTINGS FOR PROCESSING EXPORTED FILES

There are a great deal of possible settings to impose on export of the raw files. I want to take a moment to explain them, and what I select in my own workflow.

PREPROCESSING OPTIONS

Select Align Images, Crop aligned result, and taken on a tripod

Under alignment options, we want to select *Align images, Crop aligned result*, and the radio button for *taken on a tripod*. Remember, we shot this on a tripod, so selecting this option indicates to processing that there's not going to be much alignment to do. It's always important to ensure that *Crop align results* is selected by default. This is because if you moved a little bit during the shot, it's going to generate a white border around your corners that you don't want.

We will not check the option to *Show options to remove ghosts* for this series. I will go over that later in the workflow.

We want to select Reduced noise, but not for all source images. Click in the dropdown menu, and select *Underexposed image(s) only*.

Select Underexposed image(s) only from the dropdown menu

We won't select the *Reduce chromatic aberration* option here, as we've already performed this step previously in Lightroom.

HANDLING OF HDR PROCESSED IMAGE

We absolutely want to select the option to *Automatically re-import into Lightroom library*. Under the File Name dropdown we select *Combined file names*, and the export process will generate a name with the series using our original title. I select the option to *Add suffix* with "HDR" typed in; you can do whatever makes sense for you here. Finally, to get the best quality we set the Output Format to TIFF 16-bit. You have to understand that Lightroom works in 16-bit, a pro-HDR color space. All you have to understand that it's the best of the best. By selecting TIFF 16-bit, we are setting ourselves up with the best quality environment to work in Photomatix.

Select all available checkboxes, combine file names, and format as TIFF 16-bit

Now when we click on Export, Lightroom is going to create three TIFF files. The white balance, noise reduction, and lens correction are all written forever, a very important step before we move on to HDR editing. Now we're ready to jump into Photomatix and start doing some magic.

Chapter 3:
Photomatix HDR Introduction

Here we are in Photomatix Pro with our image imported from the Lightroom plugin. Let's go over what some of these settings do, and how we'll make the software work for us.

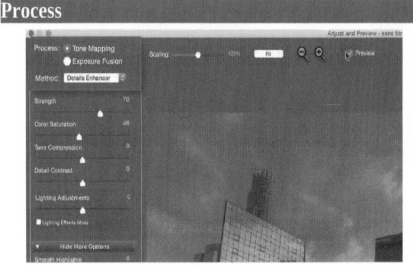

Process: Tone Mapping or Exposure Fusion

At the top we choose our *Process*, either Tone Mapping or Exposure Fusion. The best selection depends on the dynamic range of the scene, the characteristics of the source photos and the effect you want to achieve. This table highlights the main pros and cons of both processes:

Process	Pros	Cons
Tone Mapping	Can preserve details in shadows and highlights even when the dynamic range is particularly high Offers large range of settings to adjust image to one's liking Unprocessed HDR merged file can be saved	When source images are noisy, tone mapping often further increases noise Effect of settings may vary depending on the image, making it necessary to adjust settings per image to achieve a consistent look
Exposure Fusion	Fused image is close to the source photos, giving it a "natural" look Fusing the images has the effect of reducing noise Easy-to-understand process, not requiring much tweaking	Lack of local contrast when dynamic range is high, resulting in "flat-looking" image in some cases When fusing photos, memory load increases with the number of source photos

We'll select Tone Mapping; our range is high and we have more available options, but we already reduced noise considerably in Lightroom so don't have to worry as much about the usual pitfalls of this selection. I use this 90% of the time.

Following Process to the right, you can slide Scaling to make your photo big or small; additionally, you can click on *Fit* and have the image fit to your view port. With Preview selected, we see live changes we're making.

Presets

At the bottom right you can select from Built-in Presets, or any custom ones you've created. We'll click on Default at the top, which is a good starting point.

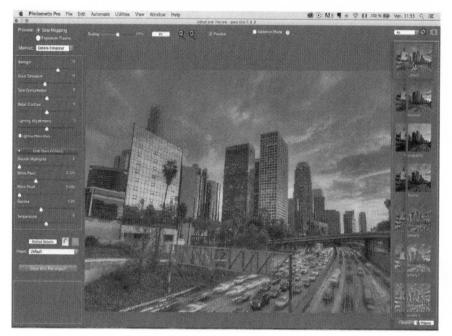

Click Built-in at the bottom right, then select the Default Preset at the top

Too much HDR

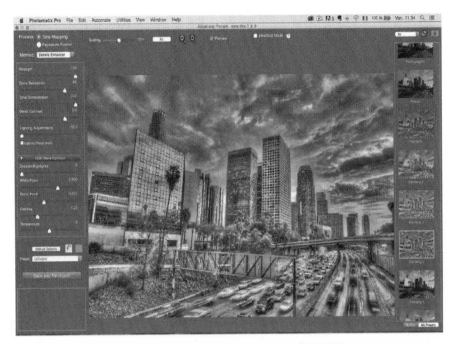

The Painterly 4 Preset—too much HDR!

Method

Since we're using Tone Mapping, we want to exploit the rich volume of options available. The Details Enhancer method is our clear choice here, because it's got the most options of available Methods. Let's look at the options one by one. Note that if you don't know what any options do, grab the slider and drag it to the extreme left or right to get an idea of its effect.

STRENGTH

Strength determines how much HDR effect is going to be employed, how much detail in the highlights and the shadows will be called out. I usually place Strength between 70 and 80.

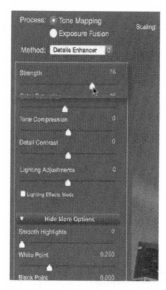

Set the Strength slider between 70 and 80

COLOR SATURATION

Color Saturation controls the global saturation of our image. I like to do a bit in Photomatix because it comes out pretty cool.

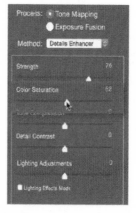

Set the Color Saturation slider to 52

TONE COMPRESSION

Tone Compression is very similar to Strength. At each extreme, everything is either very bright or very dark, bringing out and prioritizing details in either the lights or the shadows. I usually like to leave it around the middle.

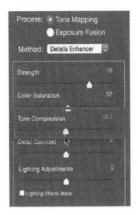

Leave Tone Compression around the middle of the slider

DETAIL CONTRAST

Detail Contrast is only an available option using the Tone Mapping process. Adjusting this slider changes the amount of contrast in the details of your image. I always set it to its maximum because I like what it does to the photo.

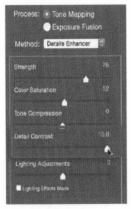

Slide Detail Contrast to its maximum setting on the right

Detail Contrast – see the difference

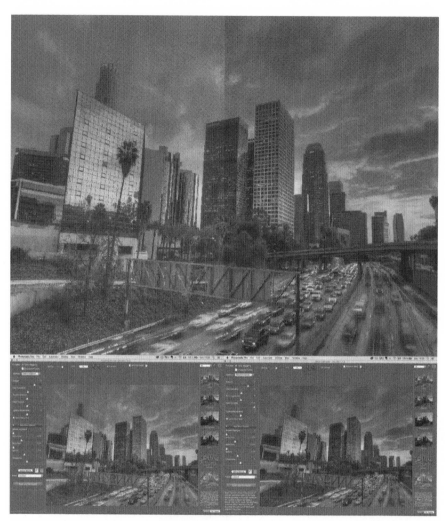

Left: No Detail Contrast changes / Right: Maximum Detail Contrast

LIGHTING ADJUSTMENTS

There are two primary methods of applying Lighting Adjustments. Adjusting the slider, if you drag to the far right, you end up with a very natural result. If you slide to the far left, you have a much more "Painterly", surreal HDR effect. You can use the slider, or you put it back in the middle and click on the Lighting Effects Mode check box to access various lighting effects.

Check the Lighting Effects Mode box to access additional lighting options

I usually select either Natural or Natural Plus. For this image, we're going to select Natural because it's bringing out more details in the buildings-- that's kind of cool.

SMOOTH HIGHLIGHTS

Then we have smooth highlights. Sometimes the process of merging different exposures can create harsh artifacts in areas of an image where the lighting rapidly shifts from very bright to dark. I like what it does because it takes out a bit of grainy effect that we have in the sky. I usually boost my Smooth Highlights.

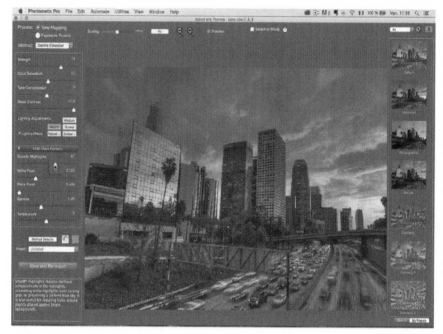

Adjust Smooth Highlights to between 60 and 70

WHITE POINT/BLACK POINT

White and Black Point adjustments will increase or decrease the tonal range in an image. You can use this slider with your histogram to keep the highlights and shadows from clipping. In practice, if you adjust White Point to the right it's going to make the entire photo brighter. If you go to the left: darker. It sits at 0,250 by default. Usually I don't play around so much with the white and black; I like to do this as my double development into Lightroom. I never touch Black Point.

GAMMA

However, Gamma I do touch because it's got some interesting effects. Gamma applies to the mid-tones. It's anything that is not bright, anything that is not too dark. I usually like to play around and lower the gamma, it adds a bit of contrast.

Slightly reduce Gamma to 0,96 to add some contrast

Wrapping Up

There you have it, those are my go-to Photomatix settings. Temperature I don't touch. Adjustments to the right add warmth, to the left add blue. But we fixed our colors already in Lightroom.

Let's recap: Strength is around 70, Color Saturation 52, Tone Compression 0, Detail Contrast adjusted all of the way to 10, Light Adjustments on Natural or Natural Plus, Smooth Highlights adjusted a little bit to the right, White and Black Point untouched, Gamma maybe just a little bit at 0,96, and Temperature at 0. These are my basic go-to Photomatix settings.

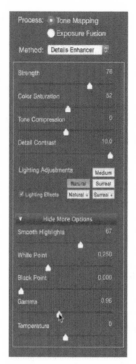

My basic Photomatix settings

I've saved this Preset as PhotoSergeClassic.xmp and it's available to you on Photoserge.com. Once you've downloaded it, all you have to do is go to Preset, Load Preset, and you're going to load the PhotoSergeClassic.xmp file. That's my basic Preset. I'm happy with that.

Finally, I'm going to click on *Save and Re-import*. This will create a TIF file and bring it back into Lightroom. In the next chapter, we'll be back in Lightroom doing some more development, this time some double processing. We still have a lot of work to do on this image!

Chapter 4:
Photoshop HDR Blending

All right so we are back in Lightroom and the photo has been re-imported. Before we proceed, let's review the difference so far between our original three exposures and the HDR one we've been working on:

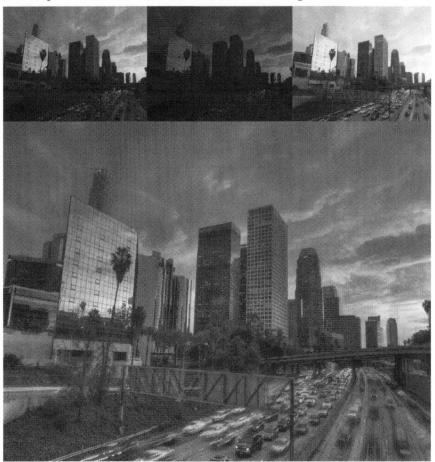

Normal Exposure, Underexposure, Overexposure, HDR—so much detail

Look at all of the details in the HDR version. I'm pretty excited. I really like the look; but there's some more tweaking to do. Now we're ready to do the double development on this one. We have some issues to address: if we look

at the bottom, the lights from the cars have generated odd artifacts in our image. It's not nice at all. We're going to have to do some digital blending to correct this.

HDR often doesn't play nicely with motion, leading to artifacts

Polishing Color

I want to perform a few corrections here in Lightroom before we move on to Photoshop. We'll be making these adjustments in the Basic panel, using the Tone & Presence sub-modules.

SHADOWS/HIGHLIGHTS

Sometimes I like to open up the Shadows a little bit and bring down the Highlights: +100 and -100, respectively. That is going to amplify the HDR look even further.

1. In the Basic panel of Lightroom, adjust the Shadows slider to 100, and Highlights to -100

WHITES/BLACKS

Next, we're going to tweak the Whites and Blacks in the image. There's a trick to seeing just how much we should adjust these: rather than simply moving the slider, we will hold down the **Alt** key (Option on a Mac) while we adjust the slider. What does this do? Holding down **Alt** while adjusting Exposure, Highlights, Whites, Shadows, and Blacks will display any areas where these particular tones are clipped. This often yields a much better view of the extent of the adjustment, and what area(s) of the image will be affected. So as an example: If we are using the Alt key and adjusting *White*, when everything on screen is black it means that nothing is 100% white or pure brightness.

Adjusting White tone using Alt key: at +29 on our image, nothing is clipped

Overuse of the White tone will completely oversaturate bright areas and lead to a bad, burned look.

Adjusting White tone using Alt key: at +89 on our image, bright areas become over-saturated

The idea is to experiment with the slider (+ Alt) until you've arrived at the "no clip" point, then adjust from there until only a few points, small points are visible. In the case of our image, adjusting from +29 up to +48 gives us exactly what we're looking for.

2. Adjusting White tone using Alt key: +48 on our image is the sweet spot

Adjusting Blacks works exactly the same way, except that we will utilize the Alt key to bring out only a small amount of pure black in the image, after locating the "no clip" region of the slider.

3. Adjusting Black tone using Alt key: -51 on our image is the sweet spot

FIXING OVERSATURATION

If at this point our image looks very saturated, there are a handful of minor adjustments we can make: increase the Contrast under Tone, then lower the Clarity and Vibrance a bit. It's still a very vibrant photo, but not over the top.

4. Final Tweaks: Increase Contrast, Reduce Clarity & Vibrance

RECAP

To recap, we re-imported the image from Photomatix, then made some final

adjustments to color in Lightroom. We improved our Shadows and Highlights by adjusting them to their polar extremes of high and low. We used the Alt key to adjust our Whites and Blacks so that there are only small amounts of visible extremes of pure brightness/darkness. And finally, we dealt with lingering oversaturation using Contrast, Clarity, & Vibrance.

Let's take a look at the difference since re-importing from Photomatix. Accessing the History panel on the left Navigator pane, we can click on the imported version further down the list, then back to our latest modification (Vibrance): Very vibrant.

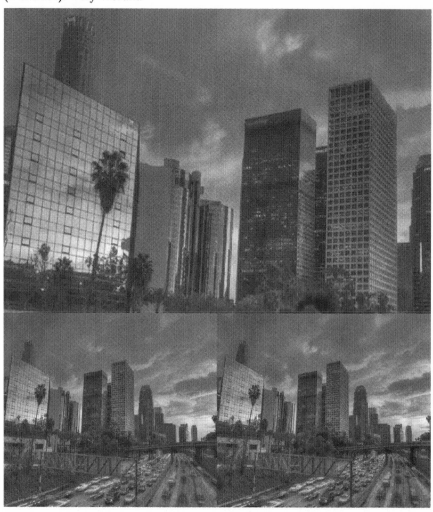

Imported from Photomatix, Color polished in Lightroom: Much more

Fixing a Region

What I'm going to do is bring our image into Photoshop along with our overexposure, because I like how the cars look in the long exposure we got from it. Before we can bring the cars over into our HDR image, however, we need to retouch them in the overexposure because they're under-saturated.

I'm just going to boost the Vibrance, bring down the Highlights, open up the Shadows a little bit, lower the Clarity a little bit, and add a bit of Contrast. There, that looks good. We're ready for Photoshop.

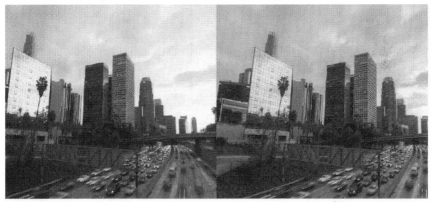

Left: Overexposure: Cars on the highway are better than HDR, but still too under-saturated / Right: Saturation of the cars has been improved; we're ready for Photoshop

Export to Photoshop

Now we're ready to take these two photos into Photoshop. In order to do that, we will use the *Open as Layers* function in Lightroom. Select them both, **right-click** either of them then find and **click** *Open as Layers in Photoshop...* under the *Edit In* sub-menu.

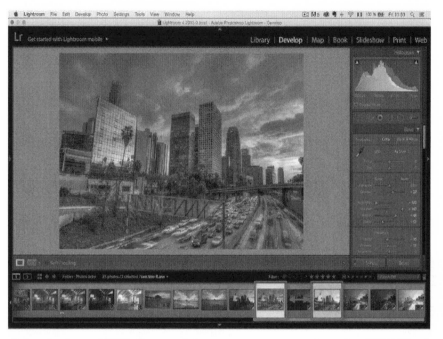

Select both our HDR photo and the over-exposure we intend to HDR blend with

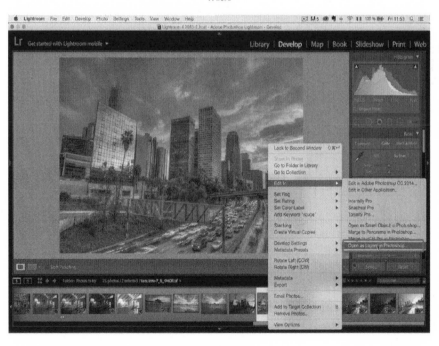

Right-click either selected photo, then navigate to Edit In > Open as Layers in Photoshop...

Photoshop

All right so here we are in Photoshop. We have one Photoshop file containing two layers: one containing our HDR photo, and the other our overexposure. If you click the small 'eye' icons to the left of the HDR photo in the upper layer, you should see the overexposure revealed.

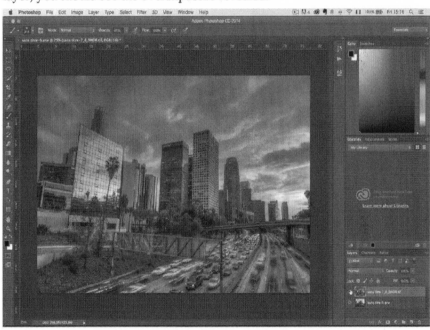

Both images exist as individual layers in Photoshop. Use the eye visibility toggle to the left of the upper layer to reveal the one beneath

HDR BLENDING WITH OVERLAYS

Before we continue, I want to show you a small trick for easy, subtle reduction of HDR here in Photoshop. After confirming that your HDR layer is above the overexposure (or other image you intend to blend with) in the Layers pane, you can simply lower the *Opacity* of the HDR layer. To do this, select the HDR layer so that it's highlighted, then adjust the *Opacity* slider to

reveal more of the layer beneath it.

Select your upper HDR layer, then adjust the Opacity slider to reveal more of the layer beneath to reduce the HDR emphasis

Now for the above to really work, you have to make sure that you shot on a tripod ideally, so that the photos are perfectly aligned. If you reduce the Opacity of an upper layer and observe weird edges appearing, this would indicate misalignment. That can be remedied! First, select all layers you wish to align from the *Layers* pane at the bottom right, then click *Edit* in the Menu bar and finally *Align Layers.*

HDR BLENDING WITH MASKS

The method above would render a more natural look, but we are going for the crazy HDR look on this one. Let's proceed. Our goal is to reveal, through our HDR photo, the bottom area of our overexposure and nothing more. We accomplish this using the Mask feature in Photoshop. In order to create a mask in our HDR layer, select the layer first then click the Mask button beneath the Layers pane.

Select your upper HDR layer, then click the Mask button beneath the Layers pane. You should now see a blank white mask linked within the thumbnail of the HDR layer

With our mask created in the HDR layer, we're ready to draw out the masked region of the layer:

1. Select the Brush tool from the left Tools menu or with the '**B**' keyboard shortcut.

2. Increase brush size by holding **Ctrl + Alt**, then holding down the right-mouse button and dragging until we've reached a desirable brush size.

Holding Ctrl + Alt and dragging your right mouse button, Photoshop visually demonstrates the brush size as you adjust it with a red circle

3. Now right-click anywhere on the image to confirm that the brush size is where we want it (in this image's case around 1300px) as well as making sure that *Hardness* is 0%.

Right-click on the image to see Brush details. Ensure that brush size is correct, and that Hardness is 0%

4. Ensure that the Brush Opacity is 100% in the top Brush menu.

Adjust Brush Opacity to 100%

5. Now using the Brush we've customized, left click and drag around the lower region of the photo containing the cars on the highway. We will also include some of the foliage to the left of the highway, as I don't like what HDR does to bits of grass. As you proceed, you will see the Mask you're drawing appear in the Mask thumbnail on the Layers pane, visible as black on the white space.

The Mask thumbnail reveals our work in miniature

6. If you want to review your mask in larger detail, hold the **Alt** key and single left click on the Mask itself from the *Layers* pane. Holding **Alt** and clicking the Mask once more returns you to the regular view.

Hold Alt + click on the Mask thumbnail in the HDR layer to view the Mask in the central viewport. Hold Alt + click on the Mask thumbnail once more to return

You can see looking at the Mask, basically anything which is black is going to be blocked on the upper HDR layer. Anything which is white is going to

be the HDR photo. This way, we've blended both exposures and now the cars from the long exposure come through, looking nice. That's great.

Our cars from the overexposure now visible on the HDR photo, eliminating those pesky artifacts

Now I'm ready to jump back into Lightroom and do a final, final retouching on the photo because I always like to. It's a bit of Lightroom, some Photomatix, some Photoshop, and then back into Lightroom. It's a multi-step work flow, but that's how you get the best result. Let's save our work in Photoshop: Click **File** > **Close**, then **Save**.

Final Retouching in Lightroom

I used to do a lot of corrections in Photoshop but I'm in love with Lightroom because I find it so much faster that now I do all that I can in Lightroom. We'll begin with some simple Lens Correction. Return to the Lens Correction panel on the right, then click on *Auto*. This should straighten our buildings somewhat.

Long straight lines straighten out using Auto Lens Correction

VIGNETTING

We're going to apply some vignetting, darkening our exteriors in order to draw the eye towards the center of the photo. To get started, select the Graduated Filters tool from the Tool strip.

1. Click on the Graduated Filters tool

From the *Effect* Presets dropdown, select *Exposure*.

2. Click in the Effects dropdown list and select Exposure

Now adjust the *Exposure* slider lower; in our case, we're lowering it to 0,95.

3. Adjust the Exposure slider lower

Now we click and drag to create an edit region where our Exposure modification will be applied. After creating it, we can move it by clicking and dragging (or hitting **Backspace** with it selected to remove it altogether). Once it's where we like it in the sky, we create another for the highway beneath. Remember that we can edit these independently by selecting the small circle for the edit region.

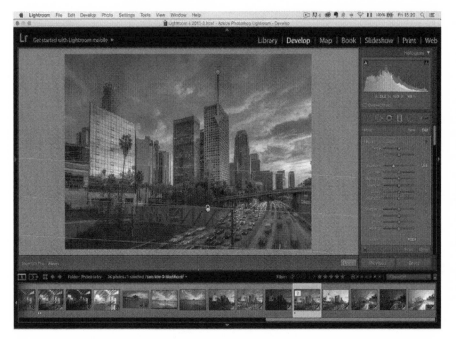

4. Click and drag on the image to create the edit regions where the Exposure gradient is applied. In this image, the 0,95 we selected previously is applied in the upper edit region. I've created a second below and reduced the Exposure even further to darken the cars. When creating the edit region, the direction dragged is the direction of the gradient.

Our vignetting is complete. It really helps to draw the viewer's eye to the center. Maybe just add a little bit of Contrast because we are going for a crazy HDR look on this photo. Voila! It was a lot of work, but I'm really happy. Let's look at the original, un-re-touched photo compared with the final HDR photo.

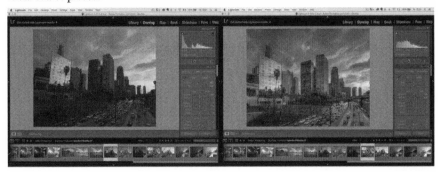

Left: Original photo, no re-touching / Right: HDR Final

Very intense. One little anecdote about HDR: If you took ten people (not photographers) and showed them ten photos where a single one is an example of *good* HDR, there's an excellent chance that they would select the HDR photo as their favorite. However, if you repeated this exercise with professional photographers it's probably the one that they'd hate the most. Most professional photographers perceive HDR as cheating. They'll find that it's just too easy.

We are just using it. The only reason we are doing HDR is because we like this very saturated look where we have details in the sky, we have details on the buildings. It's not necessarily a Painterly effect, this is good HDR. It's very saturated but believe me, that sunset was very, very saturated and I was just trying to respect it. Voila. I hope you like this. Let's move on to another project.

Chapter 5:
HDR Digital Blending

You've seen my standard workflow to achieve HDR effects using Photomatix. In this chapter, we'll go over methods for HDR blending using only Lightroom and Photoshop, getting the best out of our three raw files. You can achieve similar results using only these pieces of software. Let's check it out, starting with Lightroom.

Retouching in Lightroom

We'll begin with retouching our normal exposure, on the Basic panel. I bring down the Highlights, and increase the Shadows, under Tone. Boost the Exposure moderately, then using the Alt key like I mentioned in Chapter 3, adjust the Whites & Blacks mildly to show only the smallest amount of points.

Here are the exact modifications I made:

- Exposure: +0,30
- Highlights: -100
- Shadows: +100
- Whites: +47
- Blacks: -37
- Clarity: -6

And here's the comparison, so far:

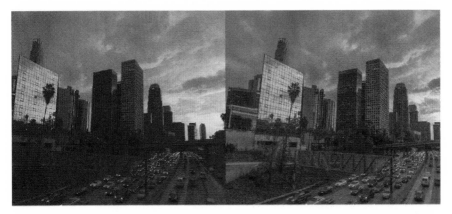

Left: Untouched Normal Exposure / Right: Retouched.

Pretty decent, it's a much more natural result. I kind of like the sky, I like the buildings, I don't like that the cars are in focus. I think it'd be nicer if they were a bit blurry and maybe I am missing a bit of sky here. I like the sky on our underexposure more, but it's too dark to be useful yet.

Switching to the underexposure now, we're going to make some adjustments while only regarding the sky; we don't care about how these changes affect other elements of the photo. Still on the Basic panel, we'll begin by opening up the Shadows (+100). Then we increase Vibrance (+35) and it's looking okay.

Now we have three pieces of a puzzle: Our normal exposure has the buildings we want, our underexposure the sky, and our overexposure has the right feel of blurred cars. Bearing in mind that we have already corrected White Balance and Sharpening, and performed Lens Correction in Chapter 1, we're ready to take all three photos into Photoshop. We'll do this by selecting all three exposures from the filmstrip, right-click any of them, then select **Edit > Open as Layers in Photoshop….**

Digital Blending in Photoshop

Now we have all three exposures occupying their separate layers in Photoshop and we're ready to proceed with digital blending. I have a very precise method to set up for this process: I always put the darkest photo on top (**click + drag** a layer to adjust its position in the Layers pane), and then I put the normal exposure in the middle and the underexposed at the bottom. You can rename the layers to reflect their exposure if that helps.

MASKING

We went over use of masks in Chapter 4. We're going to use them again, this time to perform our digital blending of these three exposures. Remember that we can use masking to reveal portions of a layer beneath our topmost? We're going to perform that on multiple layers now, to get the pieces of the individual exposures we want visible. We'll begin with the dark exposure.

We're going to add a black mask this time; essentially, rather than creating a normal white mask and using the brush to draw out the smaller mask area, we're masking the entire layer and then drawing the exception. Make sense? Don't worry, I'll show you. In order to create the black mask, we hold the **Alt** key while **clicking** the Add vector mask button beneath the Layers pane.

With the black mask added, the overexposure is no longer visible

Now we're going to use a Brush, but at greatly reduced Opacity (around 20%) and with White as the foreground color. Using the Brush, we bring back only the areas of the overexposure we want to use: the sky. So we paint around the sky and you can see that region of the overexposure returning to the deep hues we like.

We painted the sky with a white foreground brush to revive our overexposure's deeper sky. Note that the black vector mask reflects what we've painted white.

Moving on to the normal exposure, our middle layer, we're going to do something more similar to what we did in Chapter 3 using a normal mask. Select the middle layer, then again click the Add vector mask button beneath the Layers panel (with no **Alt** key) to generate a white mask. We don't want our brush foreground color to be White anymore, so we press **X** to change to black. Since the buildings are smaller, we can reduce the brush size and zoom in. I also increase the brush Opacity, since the buildings are so central to our photo. The idea here is as above: we're using the brush to draw the "hole" of transparency in the middle layer (normal exposure), so that our favorite buildings peak through from the bottom layer (overexposure).

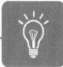

If you overdo it while drawing any of these masks, you can press Command + Z (Ctrl + Z on a PC) to revert changes.

Now on the buildings you can use a brush opacity of 50%, however this blending method won't work at such a low opacity with the cars (because of the vehicle movement between the exposures). Increasing the brush opacity to 100% solves this, bringing *all* cars from our overexposure through our normal one. Let's have a look at the result of our mask use:

Using Masks, we blended our exposures to reveal the best aspects of each

So we've mixed three different exposures in one photo: HDR digital blending. It's one of my favorite way of doing HDR, and is slightly more technical. You do lose the very popular Photomatix look, but it's important to know all of the options available to you. We're ready to head back to Lightroom. Hit **Command + W** (**Ctrl + W** on a PC) to close, then **Save**.

Final Retouching in Lightroom

Back in Lightroom we're ready to do our final retouching. We've blended all 3 exposures, so we want to repeat some adjustments: open up the Shadows, bring down the Highlights, again using the **Alt** key we adjust the

Whites/Blacks until we get some dots coming through. Very strong image here, very HDR but more natural in appearance.

Here are the exact modifications I made:

- Highlights: -100
- Shadows: +100
- Whites: +53
- Blacks: -17

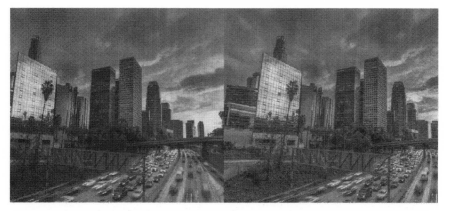

Left: Digital Blended in Photoshop, no final re-touches in Lightroom / Right: Retouched, stronger image.

I do feel that the grass is way too strong, and we'll repair it with an easy step. We'll switch to the brush with a -0,52 Exposure setting on it and make the grass darker by brushing over it.

Left: Grass is too strong, drawing the eye away from our important features / Right: Retouched grass using Brush with reduced Exposure.

VIGNETTING

We went over this in Chapter 4, we're going to repeat that process now. Again selecting the Graduated Filter tool (or pressing **M** on your keyboard) and reducing our Exposure (-0,95), we click and drag in our sky to create a gradient darkness. We do this again at bottom right over the cars to enclose the photo. Voila.

With one extra tweak, we're done. Returning to the *Lens Correction* panel, we'll select *Auto* on the Upright. Now let's compare the final product of our HDR digital blend with our earlier result from the Photomatix workflow. Can you tell which is which?

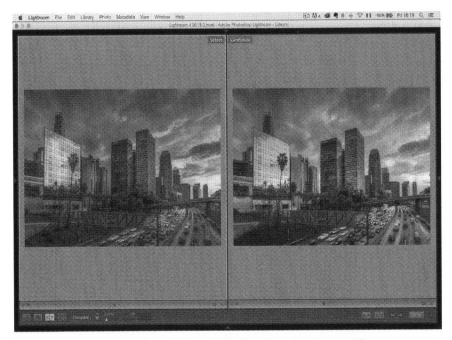

Left: HDR digital blend / Right: Photomatix workflow

TIP: You can compare two images in Lightroom this way by
1. Selecting both photos and pressing 'C', and
2. Pressing Shift + Tab to hide all other screen elements of
Lightroom

So even without Photomatix we can still do HDR and wind up with a result that looks a bit more natural.

Single RAW Retouching

There's another method, not for true HDR, but to mimic the result using a single RAW file in Lightroom. In essence, this is taking the normal exposure and trying to draw out the best result from it. We've already retouched it

considerably, but we can add a few more tweaks in the Develop module. Here is a step-by-step of how I adjust it:

1. Under the Lens Correction panel, we'll click *Auto*
2. Using a Graduated Filter (keyboard shortcut: **M**, then clicking + dragging in sky), we make the sky a bit darker
3. Use a Graduated Filter over the cars to enclose the photo
4. Using a Brush with positive Exposure (0,93), Flow/Density set around 80, Clarity set around 43, & Saturation 21 I'll bring a bit more light into the buildings

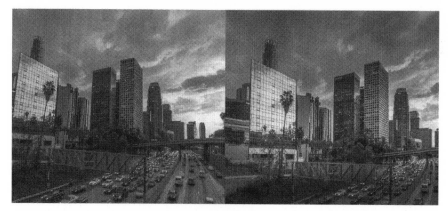

Left: Untouched normal exposure / Right: Single retouched RAW file.

Review

We've gone over three methods for preparing HDR or mimicking its effect: Photomatix, HDR digital blending and single RAW retouching. It gets richer and richer and richer. Three different techniques to try to get the best out of a scene, in our case that amazing sunset in Downtown LA. Choose your weapon, choose your workflow. See what works for you.

Chapter 6:
HDR Workflow – The Blue Hour

Here's our second project, same spot in Downtown Los Angeles. It was taken with a Canon and not a Sony, using a much wider angle and much later on into the evening. Our first project covered the sunset, this is the blue hour right after sunset. City lights are on. It was shot with a Canon 5D Mark II. I also wanted to show you this because I want to show you some more stuff in Photomatix and show you that you can also do it with a Canon.

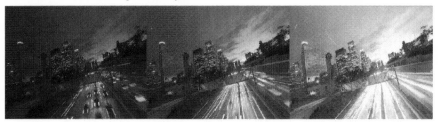

Left: Underexposure / Center: Normal exposure / Right: Overexposure

You'll notice immediately that the photo is crooked; this is deliberate, a use of the Dutch angle. It makes the road much more dynamic. Our exposure times were, from shortest to longest: 1, 4, and 15 seconds (all at ISO 100). The highway made this very nice light, and we're going to mix all of that with our workflow in Lightroom, Photomatix, Photoshop, and then back into Lightroom.

We've covered a lot of the detailed aspects of Lightroom's options in previous chapters, so as we progress we'll just discuss the specific tweaks made (starting with the normal exposure).

Lightroom Tweaks

BASIC

We begin on the Basic panel; we'll set the White Balance dropdown to Daylight, and I like what it does with this photo. On this one, I'm really looking for the colors. The Shade setting is too warm for this. We'll stick with Daylight, but add a bit of Magenta (adjust the *Tone* slider to +15).

CAMERA CALIBRATION

I'm going to jump over to the Camera Calibration panel and look at what the Camera Landscape Profile on the Canon is going to give me. I like it, it's more saturated.

DETAIL

Zooming in on the buildings, I adjust the Sharpening slider to around 100. I'm zoomed in in order to check for noise in the photo as I increase it. Not so much noise, but I'm still going to mask the Sharpening a little bit (adjust Masking to 14). We still have some very nice sharpened buildings. The Canon did a great job. Still a very good camera.

LENS CORRECTIONS

Let's check *Enable Profile Corrections* and *Remove Chromatic aberration*.

REVIEW AND SYNC

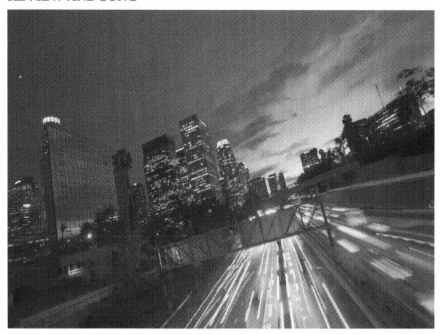

Normal exposure before any edits

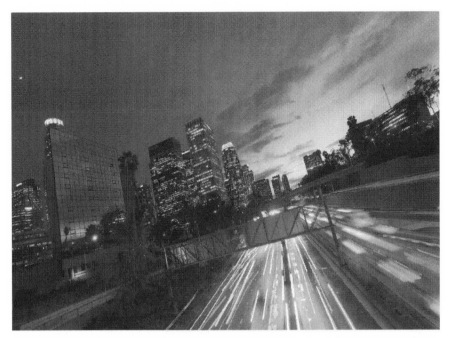

Normal exposure now

Let's do a quick review: We've changed the white balance. We changed the camera calibration to take landscape, to give a more vivid effect. Then we synchronize this on all three photos. Once again, we select all three exposures from the film strip below, then click *Sync...* followed by *Synchronize*. Now we have the same white balance, the same everything on all three photos.

Remember, on the underexposure, I usually take some more noise out after completing the Sync (adjust Luminance slider to 20 under the Noise Reduction sub-module on the Detail pane).

I'm ready to go into Photomatix. I'm going to **right-click** on the normal exposure with all three selected in the film strip, > **Export** > **Photomatix Pro**. We use the same options as in the *Wrapping Up* section of Chapter 1,

under Export.

Photomatix Tweaks

We are in Photomatix. By default, it utilized the Preset we created for our last photo in Chapter 3, under Wrapping Up. We'll adjust it slightly for this photo:

- Strength: 76
- Color Saturation: 50
- Detail Contrast: 10,0
- Lighting Adjustments: Natural
- Gamma: 0,86

METHOD

Bear in mind that we can also utilize other Methods under Tone Mapping; Contrast Optimizer is not bad, it will give a more natural result. I will never employ Tone Compression.

Before performing any edits, click a detailed region of the image to see the difference in effect between Details Enhancer and Contrast Optimizer

Details Enhancer

Contrast Optimizer

If I were to utilize Contrast Optimizer instead, I only moderately adjust the settings: Strength 80 and Midtone -2,0. I like the Contrast Optimizer for this photo, so I'm going to create another preset, Photoserge Contrast Optimizer. I'm going to give you that preset too so you can play around with it.

PROCESS

Now let's check out the other major Process in Photomatix, Exposure Fusion. We'll use the *Fusion/Natural* Method and make a few adjustments: Strength 7,3, Brightness -0,4, Local Contrast 6,4, Midtone 0, and Color Saturation 0.

REVIEW

We need to select now from our three major approaches: Details Enhancer or Contrast Optimizer under Tone Mapping, or Exposure Fusion.

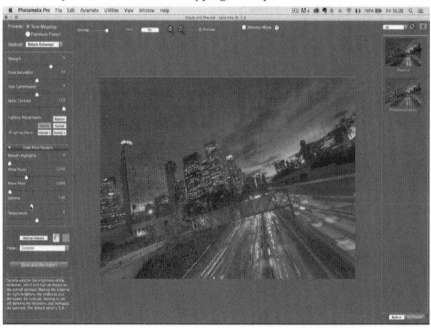

Tone Mapping > Details Enhancer Method

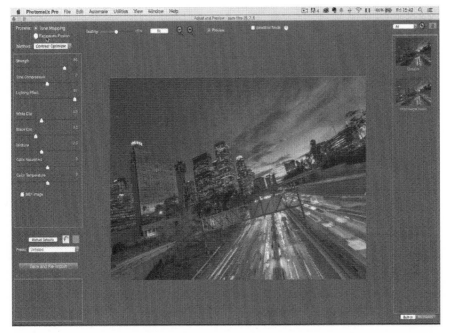

Tone Mapping > Contrast Optimizer Method

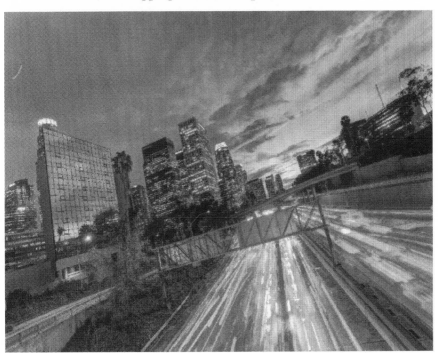

In this case, Details Enhancer still wins out for me. I'm going to save and re-import the photo into Lightroom. In the next chapter, we'll go over re-touching this photo using Photoshop and Lightroom again.

Chapter 7:
HDR Final Touches

Lightroom Polishing

We're back in Lightroom with our Photomatix file from Chapter 6, and it looks way over the top. We're going to do some digital blending with the original exposure.

Our file fresh from Photomatix, still too much HDR

First I'm going to add a bit of contrast on the Basic panel (+33) just to see how it looks because there was a lack of contrast. I like what's happening in the buildings, but I don't like what's happening in the grassy areas and the highway, the whole bottom part. We're going to need to change out the bottom part of the photo so let's see which one I'm going to use.

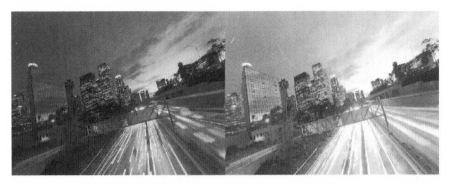

Left: Underexposure / Right: Overexposure

We have the choice between the underexposure and overexposure. I think I'm going to go for the overexposed photo, but it's just way too bright. Let's retouch this photo, for that I'm going to reduce the exposure slightly (-1,30), add a bit of clarity (+31), and increase the vibrance (+29).

Modifications to the Overexposure

Now I'm going to take our HDR photo along with the overexposure to Photoshop for digital blending. As we've done previously, we select both photos using **Command + Click** (**Ctrl + Click** in Windows), right-click on our HDR photo then select **Edit In > Open as Layers in Photoshop...**

Digital Blending in Photoshop

MASKING

We're in Photoshop now, our HDR file and our overexposure occupying separate layers. We have the HDR photo on top, if not you can simply click and drag it above the overexposure layer in the Layers panel. What we intend to do is take the best of both layers here: We want the majority of our HDR photo, but we prefer the highway and the foliage of our overexposure.

Our first step is to create a white mask on our HDR photo; we select the HDR layer, then click the *Add Vector Mask* button beneath the Layers pane. Then we use a brush tool, as we did last time, and ensure that the foreground color is black so as to draw on our white mask. Anything that we paint in black is going to create a transparency on the HDR photo, revealing that area of the long exposure beneath.

Left: Before Painting on the Mask / Right: After drawing our Mask to reveal our great highway

Check that out. We have a cool effect. If you hold the **Shift + Click** on the mask in the HDR layer, you can see before and after what the mask is doing, you can see the before and after.

TIP: If you want to subtly reduce your HDR level at this point, you can reduce the Opacity of your upper HDR layer in Photoshop to reveal some of the exposure beneath.

I'm happy with the blending of these two, so I'm going to merge the layers. We right-click on either layer in the Layers pane, then select *Merge Visible* from the dropdown. This will collapse the upper layer down into the lower, preserving our work so far in a single layer.

SPOT HEALING

We have some artifacts to address in the overexposure first, as a result of the long exposure.

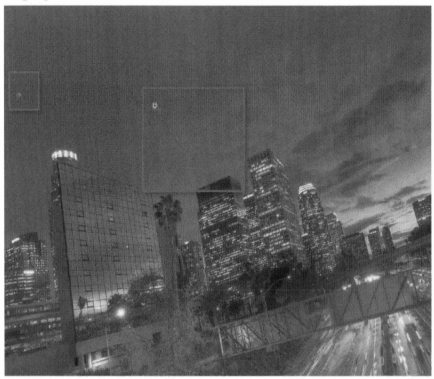

Long exposure has left artifacts that need to be repaired

Before I proceed, I'm going to duplicate the layer as a backup, a small safety precaution. To duplicate a layer can click and drag it onto the *Add Layer* button beneath the Layers pane, or right-click on the layer and select *Duplicate Layer*.

Spot Healing Brush Tool in Photoshop

I just want to tune up a bit the image here, so I'm going to go to the Spot Healing Brush Tool. We hold **Ctrl + Alt** while dragging the mouse to adjust the size of the brush tip, I use a small one for more precise, targeted changes. We grab a nice piece of the sky with a single click, then we click and drag over our artifacts to repair them with our healthy bit of sky. Voila, and I think that's about it.

1. Artifacts visible from our long exposure

2. Drawing over the artifacts using the Spot Healing Brush

3. Artifacts removed successfully

We're through in Photoshop, we've done our masking and fixed pesky long exposure artifacts using spot healing. We're ready to close and save, then re-import to Lightroom for final touches.

Final Touches in Lightroom

I'm back in Lightroom with our HDR photo and I'm going to go crazy on this one. On the Basic panel, I'm going to open up the Shadows (+100) and bring down the Highlights (-100). I'm going to hold the **Alt** key, bring the Whites (+33) up as we have before, adjusting until we see some small white points in the darkness. Similarly, we hold the **Alt** key and adjust Blacks (-51) until we see some small black points on the white. I'm going to add some Contrast (+25), and very slightly lower the Exposure (-0,15).

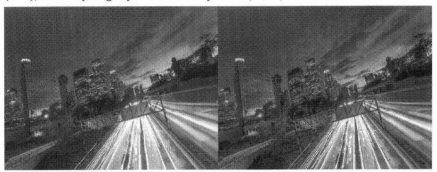

Left: Our file newly re-imported to Lightroom from Photoshop / Right: Our progress so far on re-touching

There's a little bit too much orange for me in the building, just a little bit. To fix that, I'm going to take a brush, and I'm going to add some blue (Temp: -29, Exposure: 0, Flow/Density both around 80) which is the opposite of the warm here. I'm just going to add a bit of blue in the building, a little bit here, very subtle. I'm just making the buildings a little bit more blue because I think there's so much yellow in them. Let's see the before and after:

Tip: Use the toggle switch beneath the brush settings pane to quickly view the differences in your recent edits.

Left: Before modifying our buildings with the brush / Right: After reducing the temperature of the middle group of buildings

I'm still not happy with the greenery in the image, I think it's pretty ugly. One way to make things disappear is to selectively draw there with a modified brush. I'll create a new brush, I'm going to go to reduce the Exposure (-0,38), and I'm just going to darken the foliage with the brush. I don't want too much attention on this part. Voila.

That's about it. We just added a little blue in the buildings and darkened the foliage to reduce its attention gathering. To wrap things up I'm going to into Post-Crop Vignetting and reduce the *Amount* slider (-18). It just darkens our corners somewhat to frame the image. Finally, I make a final adjustment to the overall *Exposure* (+0,15).

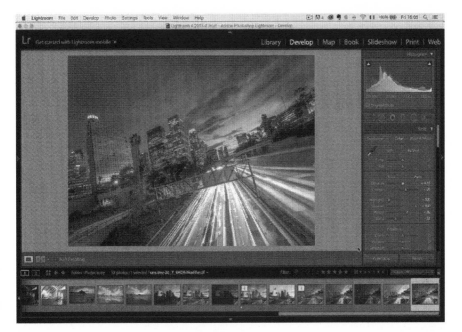

Final HDR Photo

Okay, and that's about it. I like this photo. It's very HDR, very saturated, a pretty powerful image. Hope you like this one and let's jump into another project.

Chapter 8:
Interior Design HDR

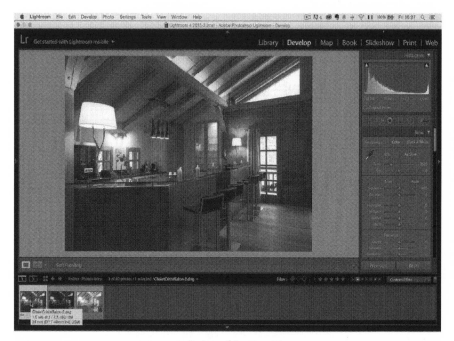

Lovely hotel in the Alps

I want to show you another project where I find that Photomatix can really help to make a photo pop. Here we are in the Alps. It's a very nice chalet and I want to show how I used Photomatix to give a special feeling to this photo.

Before we proceed, I'd like to tell you a little story of how I got into this business. I started out as an interior design photographer shooting hotels in Paris. A friend of mine was opening a hotel and had five photographers vying for the chance to shoot his hotel, myself among them. He set up a $5,000 challenge, letting each photographer shoot a room and he would select the winner from among us. I used Photomatix to HDR one of his rooms. It was a very similar hotel to the shot we're working on in this project, with a lot of wood and Photomatix on some interior design can really make your photo very special: I won the challenge because I was the only one using Photomatix. True story and that was my first paid job.

Lightroom Preparation

First, as usual, let's correct the color. We're in the Basic panel, and we'll set the white balance dropdown to Daylight; Cloud & Shade are too warm for the shot. Then we'll add a little bit of magenta as usual (adjust the Tint slider to

+14) but that's just about it.

Then, I'm going to zoom in and I'm going to do some sharpening. On the Detail panel I'm going to adjust the Sharpening Amount to around 100. On this project there's no sky so less danger of getting noise from sharpening.

On the Lens Corrections panel, I'm going to check *Enable Profile Corrections* and *Remove Chromatic Aberration*.

In the Camera Calibration panel, I'm going to check out what some of the available Profile presets are going to give me. Many of them are too red, I land on Adobe Standard as the winner.

Top Left: Camera Landscape— too red / Top Right: Camera Portrait— still

Great, we're ready to copy our tweaks to the other exposures. I select all three photos from the film strip below, **click** on *Sync...*, then **click** *Synchronize*; now all three photos have the same color. After the sync, remember to add a little bit of noise reduction specifically to the underexposed photo (adjust the Luminance slider to between 25 and 30).

Now, with all three selected in the film strip once more, **right-click** the first one and select **Export > Photomatix Pro**, then **click** Export on the pop-up window. Basically what I'm going to do is play around with Photomatix with a different algorithm, see what I like, and you will see what it does in interior design. It's pretty cool.

Photomatix

Always remember that when you launch Photomatix, it will preserve the last settings you utilized. In order to "reset", I'm going to click on *Method Defaults* towards the bottom left and we'll get going. I've gone in-depth about specific Photomatix settings in previous chapters, so I'm going to just run down my selections here.

METHOD SELECTION

First and foremost, we'll have a look at Tone Mapping > Details Enhancer (my favorite Process and Method). We'll max out Detail Contrast, select Natural under Lighting Adjustments, and increase Smooth Highlights to around 90. Here's what we've got with those settings:

Tone Mapping > Details Enhancer

Let's see what contrast optimizer is going to give me. Somehow I like more what the Contrast Optimizer is giving me. Now we can see a little bit of the snow on the outside. Not much, it's a bit out of focus, but we have a bit of snow.

Tone Mapping > Contrast Optimizer

Switching our process to Exposure Fusion, I want to show you the Fusion/Real Estate method. This one is going to give you a very nice result and works really well with real estate. Ooh, I like what it does on this one. I'll adjust the Shadows (1,1), Local Contrast (6,8). I like the feeling.

Exposure Fusion > Fusion/Real-Estate

Let's see. We have the choice between Tone Mapping, Details Enhancer, Contrast Optimizer or Fusion/Real-Estate. On this one I think I'm going to go for Fusion/Real-Estate. I like the look that it gives. I'm going to select *Save and Re-import*. This is what I advise you to do. You try these different algorithms in Photomatix, see which one you like the best. If you like it, chances are some other people will like it. Very important.

Final Touches in Lightroom

We're back in Lightroom with our re-imported photo and here it is. Voila. It's fully rendered. It's cool. Check this out compared to our unedited normal exposure; we've got a pretty natural result:

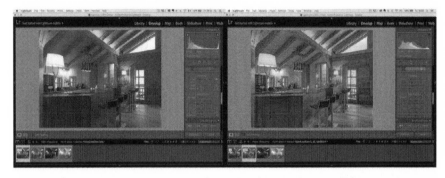

Left: Normal Exposure / Right: Edited in Lightroom/Photomatix

Let's do a double optimization on this one. I'm going to bring up the Shadows again (+62). I'm going to bring down the Highlights (-65). Using the **Alt** key while adjusting the slider once more, I adjust the Whites (+28) and the Blacks (-19) slightly. Might be a bit crazy so I'm going to bring down the shadows a little bit and not open the shadows completely and the highlights. I add a little bit of Contrast (+31) and slightly reduce the Exposure (-0,30).

It's very yellow so I'm just going to add a bit of blue (lower the Temp to -24), and add a little bit of magenta (increase Tint to +6). I like that. We have a nice mix of blue and warm. Let's have a look at "fresh from Photomatix" to now with our double optimization:

Left: Fresh from Photomatix / Right: Double Optimized

Photomatix – Redux!

As an exercise, I'm going to try another version where I use Details Enhancer. You really have to play around with all of your options to find the best look, and believe me, HDR is still very popular today. So to check this

out, I once again select the three original exposures from Lightroom and export to Photomatix.

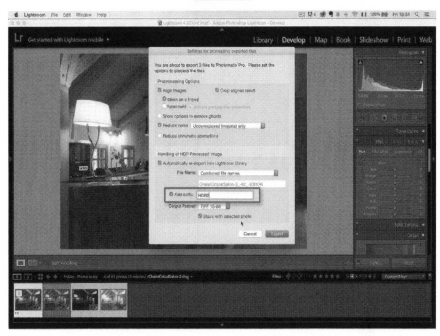

Here's a tip: If you're playing around with versioning to find the right look for your photo, use varied suffixes while exporting to maintain a clean distinction between your edits.

Back in Photomatix, I switch to Tone Mapping > Details Enhancer. I like the look that the Details Enhancer gives. I'm going to boost the Gamma a little bit (0,88), but I'll leave everything else untouched. Natural works great under Lighting Adjustments, Strength is good where it is. Time to save and re-import.

Now, what you see in Photomatix is always sort of a preview; it's going to render when you're done so when you bring it back into Lightroom it's a lot

sharper. Now that I see it back in Lightroom, there is a bit of a different quality so I'm going to go make some adjustments. I'm going to add a bit of Contrast (+40), add a bit of blue (-20 Temp) like we did before, and maybe bring down some of the Blacks (-31) and increase some of the Whites (+28).

Okay, let's compare our efforts with the two different Process/Method approaches:

Left: Tone Mapping > Details Enhancer / Right: Exposure Fusion > Fusion/Real-Estate

Wow, a lot of difference. It's a complete different feeling. Details Enhancer is cozier, but look at the details we have in the Fusion/Real-Estate version. The details are amazing.

Capturing the details: Fusion/Real-Estate on the left is dripping with details

Our Details Enhancer version has come out looking more natural, so it's a matter of taste. I really like both, but you know what, I would call Fusion/Real-Estate our winner. I think it's got more impact than the Details Enhancer effort. Yeah, I think it's got more impact, more details. I think the customer will like it more.

Anyway, I just wanted to show you the different possibilities. There are some options available to you for real estate photography, using Photomatix to give this subtle edge. Believe me, you'll make money with this.

Chapter 9:
Black & White HDR – Part 1

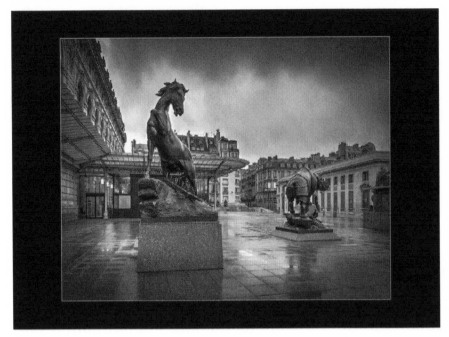

I want to show you how to do very nice, dramatic black & white using Photomatix and HDR technology. I'm going to show you 2 examples between the next couple of chapters. In our first lesson on black & white we're working with the Musée d'Orsay in Paris, which I shot very recently. I got up very early in the morning and it had just rained, there were no nice colors. I was expecting a sunrise. I have this rule in life that, if there are no nice colors, go black & white.

Lightroom Preparation

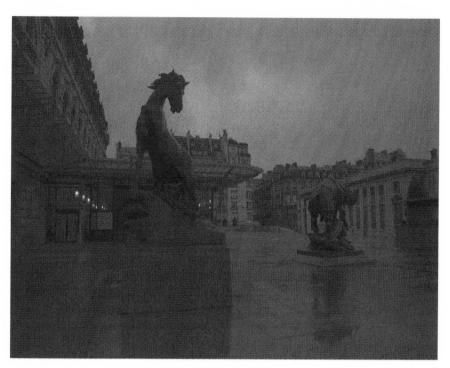

Normal Exposure

Underexposure

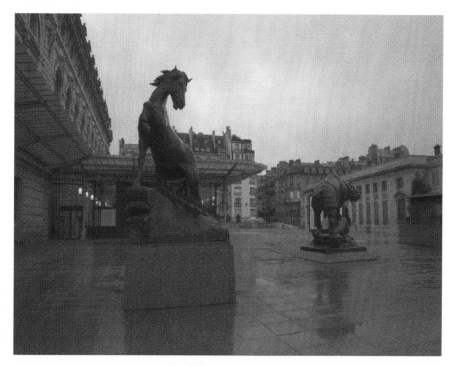

Overexposure

Before we go black & white, let's see what we can do with our shots. Look at our exposures on the right: the whole set is a little bit too dark. If you find that your normal exposure is a bit too dark, there are some tweaks we can perform before we go into Photoshop.

I'm going to open up the Shadows a little bit (+35) and the Exposure (+0,55) on the Basic panel. White Balance isn't going to do much, but I'm going to select *Daylight* from the Presets because it was very blue, and I'm going to take the colors out at the end anyway. Setting it to *Daylight* ensures that all three have the same white balance when it's time to sync. Scrolling down to the Lens Corrections panel, I select *Enable Profile Corrections* and *Remove Chromatic Aberration*, then click *Auto*.

I'm going to zoom in on the horse, and I'm going to increase Sharpening (adjust *Amount* slider to around 90), and I'm going to do a little bit of Masking (18)-- very little. I just want to take out some of the Masking effect in the sky.

Zoomed in, adjusting Amount and Masking under the Sharpening sub-module

We have a nice, tight, sharp photo, which is cool. Now I'm going to Sync these adjustments to our over/underexposures by selecting all three from the film strip > **click Sync...**, then **Synchronize**. We're ready to **right-click** on one of the exposures > **Export** > **Photomatix Pro**, then **click Export**. We're going to jump over into Photomatix and see which method of HDR is going to give the best result.

Photomatix

When you have dramatic clouds, rainy clouds; when you see contrast in the sky, you know that Photomatix is going to do an amazing job with getting all of these details to jump out. That can make amazing, dramatic, black & whites, which I want to see.

We're in Photomatix now. Remember, I'm going to give you two Presets for Photomatix: *Photoserge Contrast* and *Photoserge Classic*. The Classic Preset is my go-to setting for using the Details Enhancer method, Contrast for Contrast Optimizer. On this one, I'm going to go for the Contrast Optimizer.

Left: Contrast Optimizer / Right: Details Enhancer

Sticking with Contrast Optimizer, let's make a few adjustments. I'm going to lower the Strength (68). I want make sure there are no halos around the buildings, which is not the case, which is cool. I think the overall photo is way too bright, so I'm going to lower the Midtone (-5,4). I could take out the Color Saturation, but I'd prefer to do that back in Lightroom. We've got a very dense photo there, so I'll boost the White Clip a little bit (-5,4). Let's have a look at the contrast, after this fine tuning:

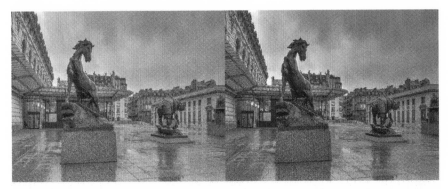

Left: Default Contrast Optimizer / Right: Contrast Optimizer Fine-Tuned

It's time to *Save and Re-import* to carry on back in Lightroom.

Lightroom

We're back in Lightroom with our photo. It's very strong, it's all blue, so I'm just going to take the Saturation out (adjust Saturation to -100) and put everything into black & white. It's already starting to look like a nice black & white.

Saturation removed for black & white

Let's do some more tweaking to this. We'll lower the Exposure (-0,15) to make it even more dramatic, increase Contrast (+25), and boost the Whites (+40) to add contrast. One thing that I think will work great on this photo is to add some serious Post-Crop Vignetting (adjust *Amount* slider to 52), so I'm going to do just that.

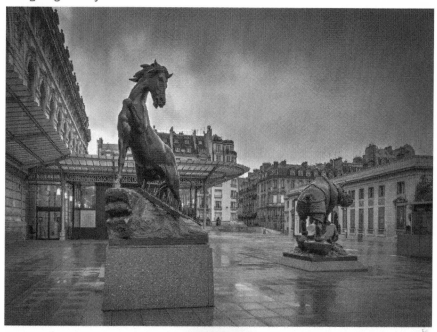

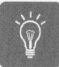

Strategic use of vignetting can look great on black & white, making the sky look very dramatic

MASK BRUSHING

We want to bring out some of the water and darker features of the horse without affecting the image as a whole. The best way to accomplish that, now that we've performed the majority of our universal tweaks, is to use a brush.

I'm going to take a little brush, and ensure that the Exposure is set to around +1 (1,20). Flow and density are around 90, that's pretty cool. I just want to make the water reflection a little bit better, and add a little bit of white on the horse and rhino. Just make the water reflection pop a little bit.

Using the Mask Brush to lighten the exposure on the puddles, rhino, and horse.

Now I'm going to add a second brush, by clicking on *New* to make a new brush at the top of the Adjustment Brush panel. This time I'm going to make it a little less powerful, reducing *Flow* and *Density* to around 75. And we'll draw in the sky, to add a little bit of additional details there.

Using the Mask Brush to lighten the exposure of the sky

Voila! We have a very, very strong black & white with lots of details. I think HDR can make you amazing, amazing, amazing black & white, and I think this one is pretty cool. You can see, in a very few minutes, by doing HDR, we can get this amazing, amazing drama in the sky. I think it's pretty, pretty cool. You might even want to add gradients at the top and bottom, to close this photo even more.

Chapter 10:
Black & White HDR – Part 2

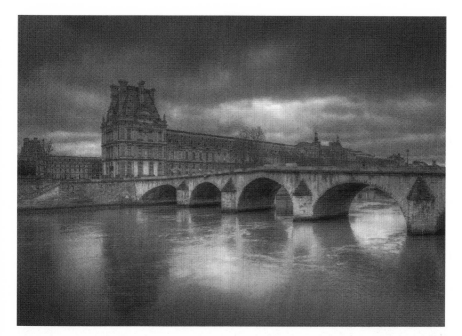

All right, I want to give you another example of black & white HDR. I think HDR is really going to help make this a dramatic photo. I developed a lot of these techniques that I'm going to show you now to make really nice HDR while working on a coffee table book of Paris. So, what better location than the Louvre in Paris to use! I went early in the morning to capture the reflection of the Louvre in the Seine before boats had begun to travel through the area and disrupt the otherwise still waters. Here the water acts as a mirror. It's quite beautiful.

Lightroom Preparation

Here is the initial normal exposure I start out with in Lightroom:

The Louvre in early morning light, and our starting point

I find this photo a little bit dark so I'm going boost the Exposure a little bit to start (+0,20). I'm not going to touch the White Balance because I'm going to go black & white, and all I want to do is *Enable Profile Corrections* and *Remove Chromatic Aberration* under the Lens Corrections panel. I'm going to click on Auto here as well:

Now we are going to zoom in to see details more clearly. Scrolling up from Lens Correction, I'll increase Sharpening (adjust Amount slider to 90). That's pretty cool. There's really no noise on this photo, that's great.

Sharpening can make a big difference as long as you're not dealing with a lot of noise!

So, then I'm just going to select all three in the film strip and synchronize them (**click Sync... > Synchronize**). We haven't done much, basically, we haven't done much. One more step before getting into Photomatix, there's a bit of noise in our underexposure that I want to treat. I'll adjust the Luminance slider to 22. Great, let's export to Photomatix.

Photomatix

I'm going to go into Photomatix and we're going to play around with it and see which one is going to give the best result, but you have to keep in mind that this is going to be a black & white photo. Why? Because the colors in our image are boring; there's no warmth. It's only blue and that's pretty boring.

Now, I'm still using these presets discussed in previous chapters, I find that between the two of them they work 80 percent of the time on HDR photos, but we can play around with them a bit anyway. Let's look at our starting points with them both:

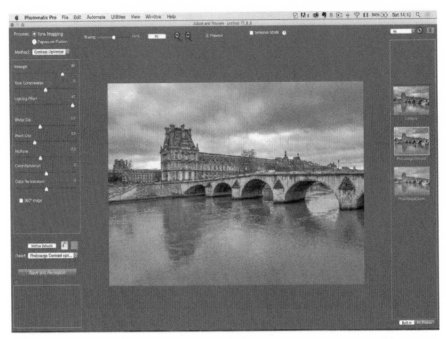

Photoserge Contrast Preset – our go-to Contrast Optimizer settings

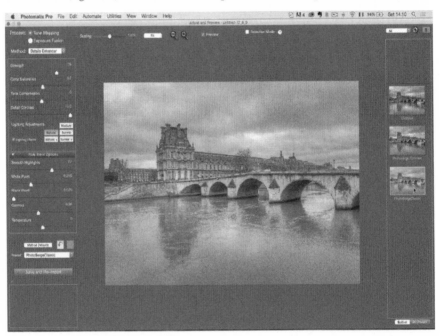

Photoserge Classic Preset – our go-to Details Enhancer settings

One thing we can do is always start fresh, from a Preset or otherwise, and then institute my basic workflow. Click *Method Defaults* at any point to reset, and we'll rapidly implement my technique for Details Enhancer:

1. Adjust Strength to around 75
2. Boost Detail Contrast the whole way to 10
3. Leave Tone Compression untouched!
4. Use either Natural or Natural+ for Lighting Effects (I went with Natural for this shot)
5. Leave White Point/Black Point untouched!
6. Lower the Gamma slightly (I went with 1,14 on this photo)

Bear in mind, we can commonly see a lot of noise in Photomatix.
Just remember that the final render will implement noise reduction.
So don't let it bug you!

All right, let's jump over to Contrast Optimizer and do a quick refresher on my go-to settings. We'll again click *Method Defaults* to remove any customization from our Preset. Here's how I'd approach this:

1. Boost the Strength (84)
2. Tone Compression left untouched!
3. Lighting Effect left in the middle

It's very straightforward, Contrast Optimizer. I'm going to go for Details Enhancer on this one. It's very noisy, full of grain here in Photomatix, but after we re-import into Lightroom the latest version of Photomatix really does a good job of erasing all that noise that we have in the photo.

Left: Photomatix showing a lot of noise in our photo / Right: After re-importing into Lightroom, the grain has been eliminated

Lightroom

Back in Lightroom, our photo looks very sharp. The light is really cool. The colors are not so bad. I could just add a little bit of Contrast (+43 on the Basic panel) and leave it this way. But let's look at using virtual copies.

VIRTUAL COPIES

Virtual copies are a little different from snapshots. It's still a form of versioning, but virtual copies receive some special treatment in the film strip; you can easily tell them apart by a small curl at the bottom left of the thumbnail. This way there's a better "at-a-glance" idea of your "black &

white" vs color, for example, in the film strip. To create a virtual copy, we **right-click** on the exposure, then select *Create Virtual Copy*. Now we can take out the colors in our virtual copy (adjust Saturation to -100).

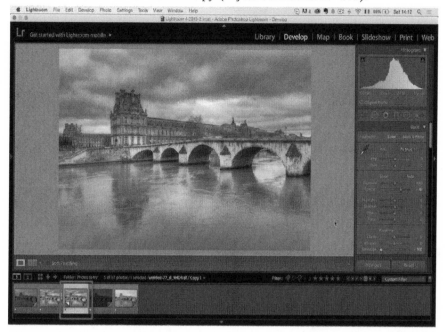

Our black & white virtual copy—note the curl on the film strip thumbnail for us to easily distinguish it from our other exposures.

LOCALIZING CONTRAST

Now, when you pick out the colors and you want to make black & white HDR, let me give you a couple pieces of advice. You see, right now, our photo is very grayish. There's a lack of contrast. So, I'm actually going to revert the overall Contrast (re-adjust the slider to center) and we'll apply contrast "locally". How do we do it? Using gradients.

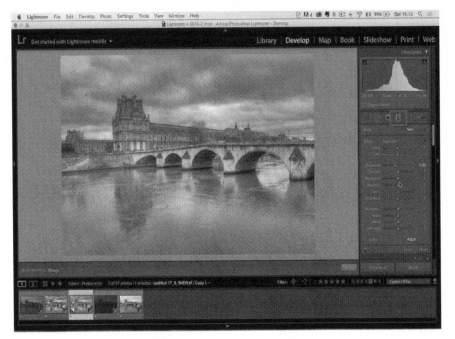

1. Select the Gradient tool

We'll use the Gradient Filter tool in two passes. One first pass to reduce the Exposure in the sky a little bit...

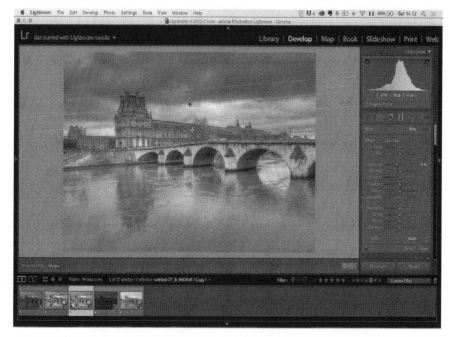

2. Drag down a gradient of reduced exposure in the sky

...then we click on *New* at the top of the Gradient Filter panel...

3. Click New at the top of the Gradient Filter panel to stop editing our existing sky gradient and begin work on another

...and we drag out a second gradient in the sky, beside our first.

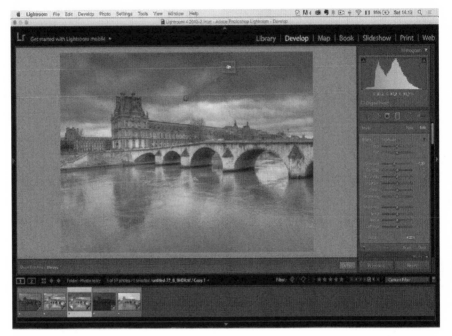

4. Drag down a second gradient of reduced exposure in the sky, about an inch above our first

We've got the gradient in our sky now, and we'll follow it up with a slanted one beneath, in the river facing the bridge:

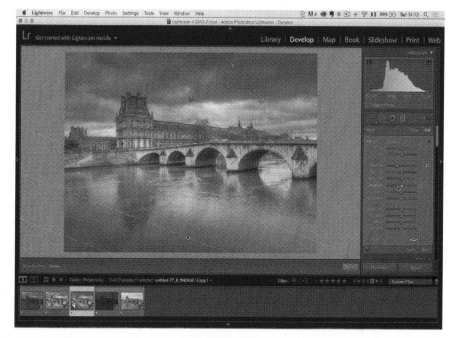

5. *Create a gradient at the bottom of the photo now, dragging up*

When working with Gradients, remember that length determines the sharpness of the gradient

Left: A short gradient: Very severe edge on the gradient boundary / Right: A long gradient: Smoother gradient transition, much more ideal

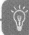

So, that's kind of cool. Let's look at the before and after with our gradients:

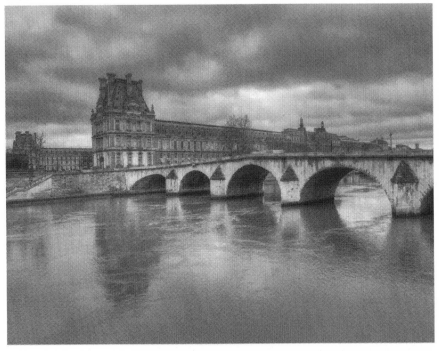

No gradients

With our 3 gradients, 2 in the sky and 1 in the river

EXPOSURE BRUSHING

We're looking good, but we can do a bit more to bring out the details we want in the black & white. We'll lower our whole exposure (-0,40), and reduce the highlights (-63) to make it a little bit more gray. I'll also increase the Contrast a small bit (+16). Okay, that's kind of cool.

And now I'm going to take brush. I'm going to put a plus exposure. I want to make sure the reflections in the water are more visible. So, just paint here a little bit. Voila! New brush and same thing, add a bit of white here in the sky to make it more interesting.

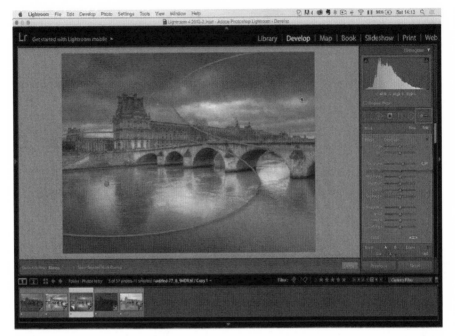

Using the Brush tool with a heightened exposure, you can bring out desired details in black & white HDR to great effect. We've used it for the Louvre's reflection in the river as well as to lighten the sky

So, it's pretty fast. A little bit of brush and voila!

CROPPING

Now I'm going to crop this image; it's not totally straight, but we can easily fix that with a few steps:

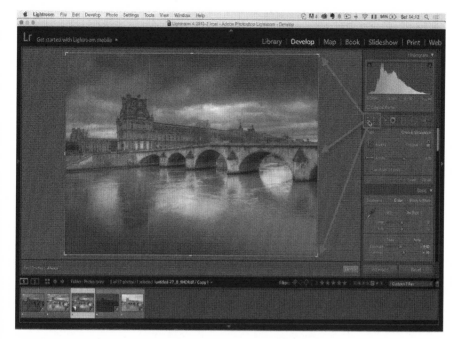

1. Select the Crop Overlay tool from the Tool strip. You should now see a grid overlay on your image

Using the Crop tool, we can click and drag outside the bounds of the image in order to adjust it on a left or right slight:

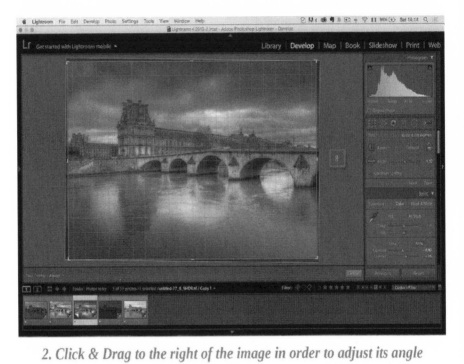

2. Click & Drag to the right of the image in order to adjust its angle

…then select a border of the image and drag in or out in order to resize it within the viewport:

3. Click on a border of the image and drag in or out to resize it

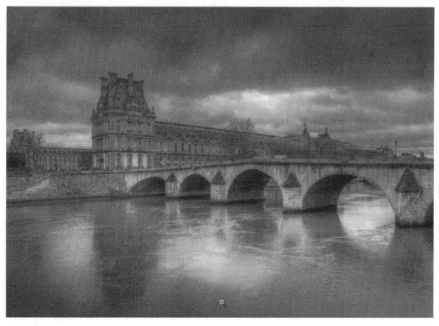

Voila. Cropping done, and our image looks much more panoramic

Then I'll just add a bit of vignetting (adjust Post-Crop Vignetting Amount slider -22 on the Effects panel). And at this point, I'm going to do my Whites and Blacks. As before, we hold down the **Alt** key while adjusting the sliders just enough to see a few small details emerge:

Hold down the Alt key while adjusting Whites & Blacks to see the Masked change in the viewport. We just want to see some minor details emerging

You know, when you do the Whites and Blacks, it's kind of important on the Blacks to really have some areas that are completely black. It's going to make the entire photo really pop. Okay, I think it's looking pretty good. I may tweak the noise reduction a little bit. There is a little bit of noise, but not that much. It's kind of pleasing, actually. So, very nice black & white. Let's have a look at it versus our original color version:

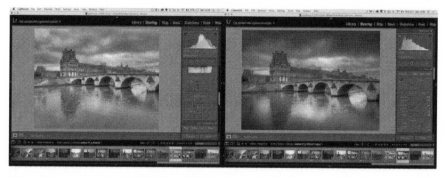

The color version isn't bad, but I think the color looks very fake because the green from the river is too green. If you wanted to use it, you could lower the Exposure somewhat to try making it more realistic, but this is still an example of black & white being the real solution. I think it works really well on this photo, a very sharp photo of Paris that surely would go into my book. So, that was our second black & white HDR. Let's jump onto another project.

Chapter 11:
HDR Deghosting

What is Ghosting?

Ghosting results from objects moving in the frame from shot to shot when you're shooting a bracketed sequence. Say, for example, a bird flies across the sky. It will be in a different position in each shot. When the images are merged together, you can end up with a semi-transparent ghost of a bird in different spots across the sky.

Not this type of Ghosting

Both Lightroom and Photomatix offer some options for "de-ghosting". While there's no "right" setting for this–it varies from shot to shot and personal preference to personal preference–in general you want to apply as little deghosting as you can get away with. The reason is that you can end up with some pretty ugly side-effects. There's no way to apply it in only one part of the image, so you might end up fixing the bird ghost but introducing other problems elsewhere in the image. And sometimes you get better results with living with the ghost in the HDR merge and then removing it with the healing brush later.

Introduction

On this project, I want to show you how I approach de-ghosting with Photomatix. I've selected a photo that will be a good example: this is an HDR photo we're going to do of a Scottish tavern, The Highlander. There can be only one in Paris (see?). I love this place; it's a great spot to take nice photos because it's got great lights in it.

The Highlander – a corner of Scotland in the heart of Paris

This is a normal exposure. Now look at the flags. Because there was a bit of wind, the flags are blurry. However, on the underexposure, because it is a shorter exposure (only one-fourth of a second when the normal exposure was 1.6 seconds), the flags are not so blurry. A bit blurry, but hardly. You see?

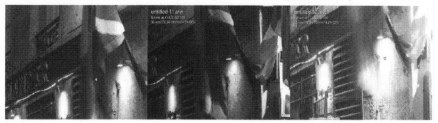

Left: Normal exposure (1.6 sec): Flags are blurred due to wind / Center: Underexposure (0.4 sec): Flags are hardly blurred / Right: Overexposure (6 sec): Flags are completely blurred

On the long exposure, the flags are completely blurry. How is Photomatix going to deal with that, the movement between the three photos? I'm going to show it to you.

Lightroom Preparation

Remember, there are three things we do with raw files before heading to Photomatix: colors, noise, and lens correction. We'll start on the Basic panel. On this one, I shot it on Tungsten (adjust the WB dropdown to Tungsten before customizing). I'm going to add a little bit of warmth to it (adjust Temp slider to 3104 and Tint slider to +16).

1. Adjust colors first: Temperature & Tint

Okay, I like the colors there. Now we scroll down to the Detail panel, I'm going to address the noise and sharpness. I'll adjust the Sharpening/Amount slider to around ninety, and let's do a little bit of noise reduction on this one (adjust the Luminance slider to 10).

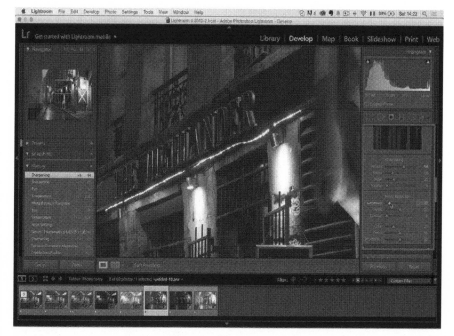

2. Zoom in while adjusting sharpening/noise reduction to see your changes

Final step before we sync, is head down to the Lens Corrections panel. We select *Enable Profile Corrections, Remove Chromatic Aberration*, and click *Auto* to straighten the photo somewhat.

3. Lens Correction: Check the usual two boxes and click Auto

Now select all three photos from the film strip, click **Sync...** > **Synchronize**. Okay, that's the usual workflow. Then I'm simply going to boost the noise reduction on our underexposed photo to about thirty (**Detail** panel > **Noise Reduction** sub-module > adjust **Luminance** slider).

We're ready to jump into Photomatix, with a minor but significant difference

in our export procedure. Select all three exposures from the film strip, then **right-click** one of them for the context menu as usual. Hover over *Export*, then **click** *Photomatix Pro*. This time I am going to select the option to *Show option to remove ghosts*:

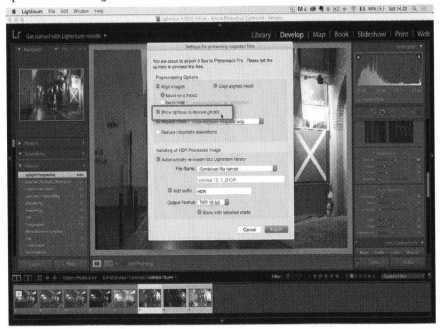

Select the option to Show options to remove ghosts in export settings

This will perform an export of all three photos, but we're going to be presented in Photomatix with a new window to help us with our flag trouble. Let me show you how this works.

Photomatix

SELECTIVE DEGHOSTING

Deghosting Options in Photomatix

All right, here we are. There are two primary methods for deghosting: Selective Deghosting and Automatic Deghosting. I would rather use the Selective Deghosting; you'll see, it's very simple. Here's the process: Using your mouse, click + drag a circle around the problem area, in this case our flags:

1. Click + drag your mouse cursor around the area to deghost

...once we've drawn our circle, we simply have to **Ctrl + Click** or **right-click** within the circled region to confirm it as ghosted:

2. Ctrl + Click (right-click on a PC) within the selected area, then select
Mark selection as ghosted area

Once you've marked your selection, the dotted line of your circle should become solid. The next thing we want to do is select *Preview Deghosting* on the left to see what Photomatix plans on doing with our exposures:

Left: Our marked deghost region / Right: Deghost preview—still pretty blurry

As you can see, the flags are still pretty blurry. Why is that? Let's click *Return to selection mode* on the left, then **Control-click (right-click** on a PC) inside of our deghost region again. The menu has changed slightly: it includes the option to *Set another photo for selection*. When we hover over it, we can see all of our exposures, and presently our underexposure, the one we really want to use the flags from, isn't checked. Let's select it now.

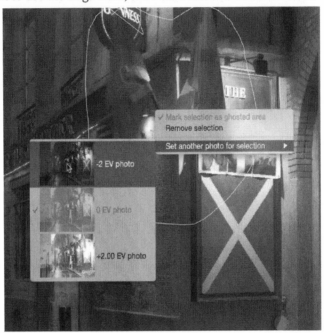

Right-click in selection area, then set our underexposure for selection

Now we click *Preview Deghosting* once more and the flags are nearly immobile—almost no blur. That's very important. The underexposed photo is often the answer, in deghosting, because it's got a shutter speed allowing for the sharpest objects.

Left: Blurry deghost preview with just the normal exposure in selection / Right: Deghost preview with underexposure added—no more blurring

Now I can click on *OK* at the bottom left and we proceed to the standard Photomatix screen.

METHOD & PROCESS

We're going to explore the different Photomatix options to see what is going to work best for this photo. Every project has different settings, and the more HDR projects you see the better off you'll be in making your own choices. I think Contrast Optimizer is going to give us the best result on this photo.

We'll increase the Strength a bit (+74), Tone Compression I'm not going to move. I'll adjust Lighting Effect as well (+73). Finally I'll reduce Midtone somewhat (-4). I always like to play with the Lighting Effect and Midtone because as you adjust the Lighting Effect to the right, every shadow becomes more visible. As you move the Midtone to the left, it's going to make the whole photo dark. It makes for a nice effect. Let's compare Details Enhancer with my standard workflow settings to Contrast Optimizer:

Left: Details Enhancer with PhotoSergeClassic Preset / Right: Contrast Optimizer with PhotoSergeContrast Preset

Contrast Optimizer wins. I'm ready to save & re-import to Lightroom.

Lightroom: Redux

Back in Lightroom with our HDR photo

Not bad at all, I would say. Look at the flags, they're pretty sharp for an HDR photo. We took the sharpness of the underexposed photo and combined with our HDR work for the best of all worlds. Let's do some final tweaking now.

On the Basic panel, I'll add a little bit of Contrast (+38) as well as open up the Shadows somewhat (+53). I like the look that gives. Check out how on the normal exposure, the sign for the establishment is completely blown out, and with the HDR, we can see what's happening:

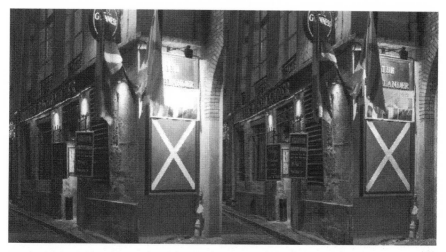

Left: Normal exposure: Can barely make out the sign / Right: HDR photo: Look at that! Words!

We'll add some Post-Crop Vignetting down on the Effects panel (adjust Amount slider to -37). I think it's going to work nice. We'll slightly lower the Highlights back on the Basic panel (-27). A little bit, not too much. I play with the Vibrance and the Temperature, but I like them best left alone. I take out just a little bit of Magenta (adjust Tint slider to -11).

I want to crop this a little bit because I don't like the left wall so much. I played with it, trying to remove the wall but we ended up too "in" the photo. In the end, I opt to just crop some of the bottom to make the photo a bit more panoramic.

Use the Crop Overlay tool to play with the final appearance of your scene

That's pretty much it. We got the tavern. Then it's just the final touching of what you like or what you don't like. I end up taking a Brush with some slightly increased Exposure and brushing over some areas where I want to see a little bit of light. I make sure to hit some vibrant areas of the walls and reflections in the street puddles. Let's see the before/after of the brush stroke:

**Use the History toggle at the bottom of the Adjustment Brush panel
to see your before & after**

Left: Before adding some Exposure with the Brush / Right: After adding some Exposure with the Brush

It works out well, just makes the photo pop a little bit. That's a classic sort of real estate HDR. It works really well because there's a lot of nice lighting and it's just a cool place. Voila! Those are the tools to deghosting. See you in the next chapter.

Chapter 12:
Seine Deghosting

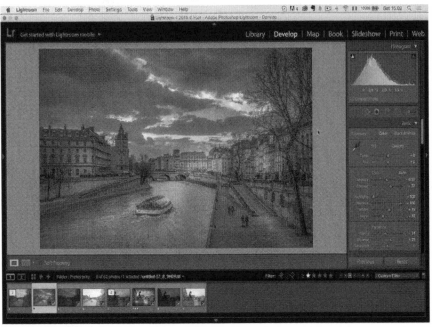

On this project, I want to show you two things. The first is alternate methods of deghosting. I also want to show you how you can start with a very blah photo with kind of a boring sky, and how HDR really brings out colors you would not suspect to be there. Let's have a look at our exposures.

Left: Normal exposure / Center: Underexposure / Right: Overexposure

Note that the boat is moving a little bit between the 3 shots; that's something we're going to try to correct with deghosting, and I'll show you two ways of going about this.

Lightroom Preparation

First, let's look at some colors. I'll adjust the White Balance Preset to *Cloudy* from the dropdown, then add a little bit of magenta (adjust Tint to +21). We don't have a lot of color to work with, but those changes help.

Now sometimes, there's something you can do to cheat a little bit and have the HDR introduce more colors. You can see here, there is a bit of sunset happening in the middle of the photo, there's some warmth there.

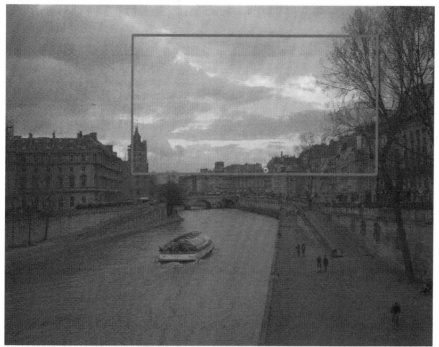

We spot a little bit of color to work with at the center of our sky, just above the row of structures

I want to increase that. Here are the steps we'll take:

1. Select the Radial Filter tool (keyboard shortcut: Shift + M)

2. Change the Effect dropdown in the Graduated Filter panel to Temp. (This will set everything to 0 other than Temp)

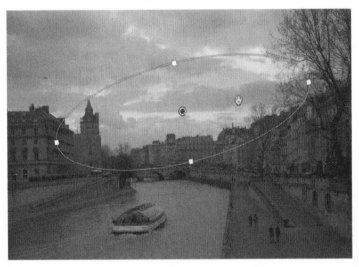

3. Click and drag in the sky to create an oval roughly covering our desired region

4. Check the box to Invert Mask and boost Feather to 100 at the bottom of the Graduated Filter panel

5. Add a bit of warmth using the Temp & Tint sliders

Our adjustments there will end up on all three photos. It's very subtle but you will see at the end it does do something. All right, I'm fine with the colors now. Next, we move on to the Lens Correction panel and, you guessed it: Check *Enable Profile Correction*, check *Remove Chromatic Aberration*, and click *Auto*. Terrific.

We scroll down finally to the Camera Calibration panel. We want to see if we can get just a little more color out of this, let's have a look at what an alternate profile can do for us. I select *Camera Landscape* from the Profile dropdown—yeah. Camera Landscape is already bringing in more colors.

Switching to Camera Landscape gives us just a bit more color

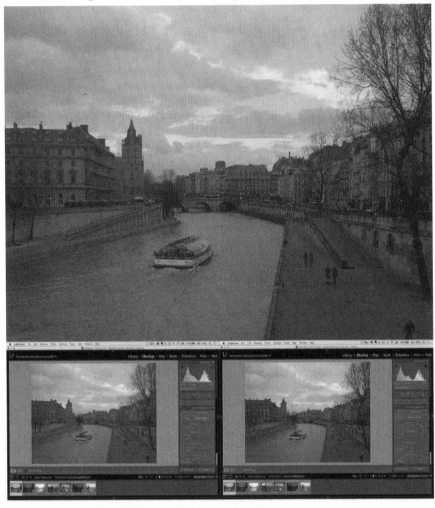

Left: Adobe Standard / Right: Camera Landscape

Okay. I'm happy with that. Our final step in Lightroom prep is heading to the Detail panel. I'll increase the Sharpening (adjust the Amount slider to around 90), then slightly increase the Masking while holding the **Alt** key (to show the negative exposure) to around 15. It's sharp just where we want it.

One thing I don't like so much is that the water is a very high frequency texture. In fact, our sharpening made it even worse! We still like what it did for us in the rest of the photo, so we're simply going to repair the sharpening on the water using a brush. Switching to the Adjustment Brush panel (use the **B** key or **click** the Adjustment Brush tool from the Tool strip above the Adjustment panels), I'll **click** in the Effect dropdown and select Clarity. Everything is going to be set to zero except for Clarity.

Select the Adjustment Brush tool, then select the Clarity Effect preset

Now, *reduce* the Clarity (adjust Clarity slider to -45) and the Sharpness (adjust Sharpness slider to -45) of the Adjustment Brush. Then, I'm going to paint over the water, because I don't like when the water is too sharp. I think it hurts the eyes. Let's take a look at the before/after on the water:

Text: Use the History toggle to track and observe changes with the Brush tool

Left: Before / Right: After

See how the water is less sharp. It's very subtle but we know that the HDR is going to increase a lot of the sharpening. If it was *very* sharpened, I wouldn't like that. Finally, we'll head down to the Noise Reduction sub-module and increase the Luminance to about 10.

All right, we're ready to synchronize our changes across all three photos. Select them all in the film strip, **click Sync... > Synchronize**. Then we simply want to increase the Noise Reduction for our underexposure separately (adjust Luminance on the Noise Reduction sub-module to 30). We're ready to select all three photos again, **Export > Photomatix Pro**. As in the last chapter, we want to ensure that on our export settings, we select the

option to *Show options to remove ghosts.*

Photomatix

DEGHOSTING

Here we are in *Deghosting Options,* in Photomatix Pro. Remember, on this one, I'm going to leave Selective Deghosting selected. The area that we want to focus on first is the boat, as we know it's moving through the exposures. So I'll **click + drag** the mouse cursor around the area where the boat is moving:

1. Click + drag to select the ghosted region

Then, we **right-click** within the circled area, and select *Mark selection as ghosted area:*

2. Right-click in the selected ghosted region, then click on Mark selection as ghosted area

The dotted line has become solid—this is important, because we can now move on to select additional ghosted regions of our photo; namely, the people! Once again, we **click + drag**, this time over our moving couples on the walkway (and each time, **right-click** + *Mark selection as ghosted area* to solidify the path) until we have all of our ghosted regions selected:

3. Repeat steps 1-2 above for all areas where ghosting occurs in your shot

Now as before, we want to ensure that we're including our underexposure in the selection for repairing the ghosting. Once we've got all of our ghosted regions selected, we **right-click** again in one of them, **Set another photo for selection** > select our underexposure:

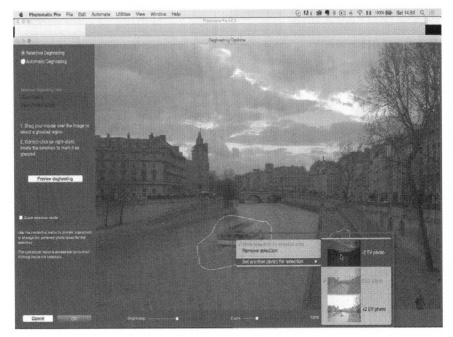

4. Right-click again and select the underexposure for selection

Let's preview this—looks great. Remember that last step about choosing the underexposure for your selection. Usually it's going to be zero EV (normal) or minus 2 (under). On this one, I would go for minus 2; the shortest speed is giving us the sharpest items. We're done, we **click OK**, and Photomatix Pro will busy itself merging the deghosting effect with the HDR.

HDR

Time to check our Preset and see how we can make this pop. The photo looks a *lot* nicer now. Here's what we get for our two Presets without any customization:

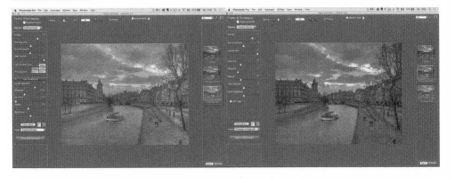

I like what Contrast Optimizer is doing on this one. Let's work with that
Preset and play with the options a bit. I'll boost the Strength a little bit more
(adjust Strength to 90). Always remember that maximizing Lighting Effect
and then reducing Midtone dramatically is a good way to make things very
intense. I'll also add a little bit of Color Saturation just to be a bit more crazy
(increase Color Saturation to 1). Here's what we've got:

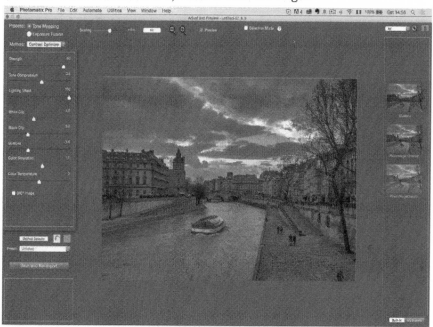

Contrast Optimizer, after tweaks.

That's the best I can get from Contrast Optimizer. Let's jump over to Details
Enhancer at the top left (under the Method dropdown) and see what we can
get there. I like Natural Plus more than Natural for this shot, under Lighting
Adjustments. I think I'm going to lower the Gamma on this one (adjust
Gamma to 1,08). I add a little bit of Color Saturation (62). Okay. Let's
compare the two methods, with our tweaks:

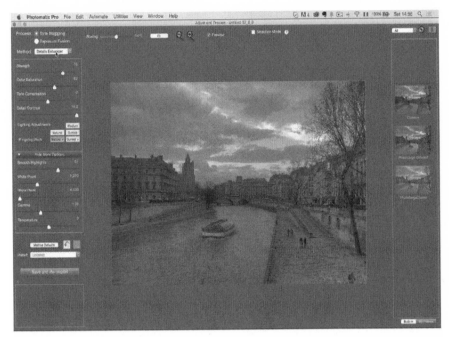

Details Enhancer, Post-Tweaks

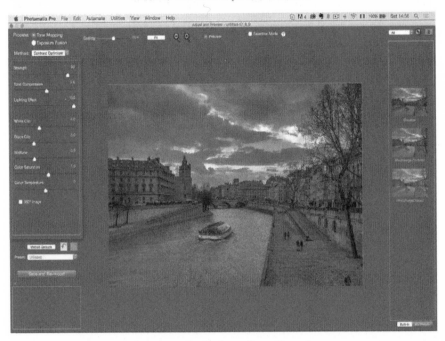

Contrast Optimizer, Post-Tweaks

Contrast optimizer wins, for me. It will also give you a more natural result. I used to use Details Enhancer quite a lot, exclusively, but once I used Contrast Optimizer enough I started to consistently see nicer results from it. The final render is a bit more natural, a bit more organic. So we've got our choice, let's jump over to Lightroom and see our final Photomatix render there—just click *Save and Re-import* at the bottom left.

Lightroom Final Touches

Check it out—now we've got a very sharp boat due to our deghosting efforts, that's pretty cool:

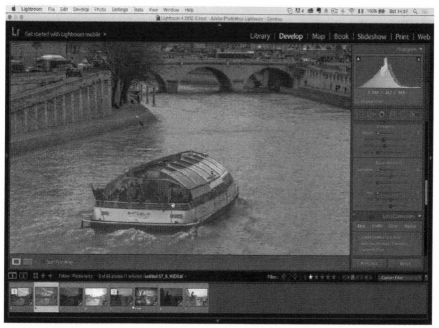

Deghosted boat back in Lightroom, looking great with no blurring

See how the boat is very sharp? I like that. The people are also very sharp, it's really cool. There is another method of deghosting involving Photoshop; similar to our masking in previous chapters, we'd take the normal and overexposure to Photoshop as layers, then use clever masking in order to reduce our ghosting problems there. But the Photomatix deghosting did such a good job that we don't need to!

We've got this lone individual at the corner of the shot I don't like. It's a bit blurred and out of place. To remove them with some ease and also get more

of a panorama shot, I'm going to cut out some of the bottom with the Crop tool:

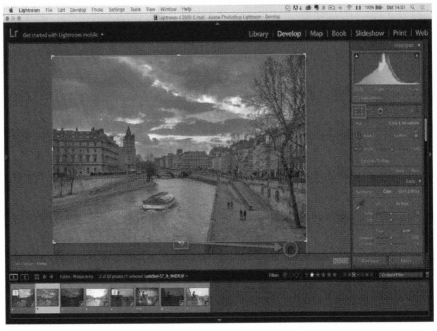

Select the Crop Overlay tool, then click + drag up from the bottom to eliminate that individual from the corner of the shot

I'm going to leave the nice Parisian couples walking, I think they're kind of cool. Now we're going to check out a double development. On the Basic panel we'll open up the Shadows (+100) and bring down the Highlights (-100). We'll adjust the Whites (+24) and the Blacks a *lot* (-53) while **holding Alt**, enough to get some features coming through. The Blacks makes a big difference in the photo.

Holding Alt while adjusting Blacks, we can see/adjust the areas that are 100% Black in the photo

We can increase the impact even more by adding Contrast (+27) and Vibrance (+25), but we match it with some Temp (+8) and Tint (+6) for a bit of yellow and magenta to match the crazy blue of the sky. Okay, we've got nice colors. Let's review with where we came from:

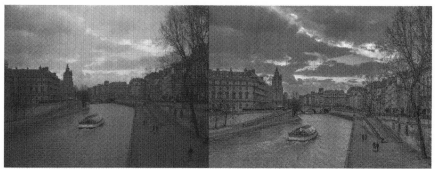

Left: Original normal exposure / Right: HDR

We came from THAT exposure and this is where we are! See how the HDR really boosted it? I'm not even finished with it. I'm going to do a little bit of

post-cropping here (-22). This one's kind of funny because it's very sharp, it's got an almost cartoonish effect to it. A slight Clarity reduction (-14) will take out some of the sharpness and make it a bit more organic. I'll lower the Exposure very slightly (-15), and I'm ready to move on to brushing. I think the global colors are great.

Looking good—nearly done

DODGING

At this point, sometimes what I like to do is take the Adjustment Brush with the Effect set to Exposure and play around adding some *dodge*. By dodging, I mean turning some parts of the photo into *deviations* (in this particular case, brighter!). I'm just painting the water to make it a little bit brighter:

Left: Before brushing exposure / Right: After brushing exposure

I'm usually brushing with Flow and Density set to around 75-80. That's the power of my brush. Another cool way to add some dodge is to use the Radial Filter to add some spot lighting. Let's walk through it—the first thing I do is select the Radial Filter from the Tool strip, and make sure that the Effect is set to Exposure:

1. Select the Radial Filter tool from the Tool strip

Now I'm going to draw out a Radial Filter on this building on the left:

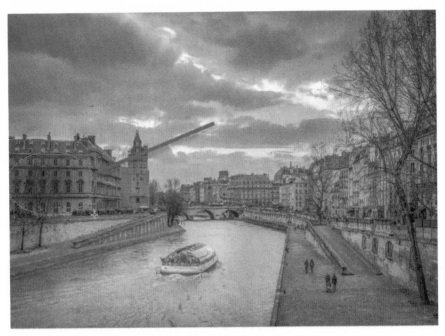

2. Click + Drag to draw a Radial Filter

Now we max out the Feather of the Radial Filter (100) and check the box to Invert Mask, at the bottom of the Radial Filter panel:

3. Adjust Feather to 100 and check the box to Invert Mask

Now that we've got it set the way we like, we can feel free to duplicate this filter elsewhere in our photo:

4. Right-click on the Edit button of the Radial Filter, then select Duplicate

Then we can **Click + Drag** our duplicated Radial Filter to our new location (note that the original Edit dot remains where we placed it:

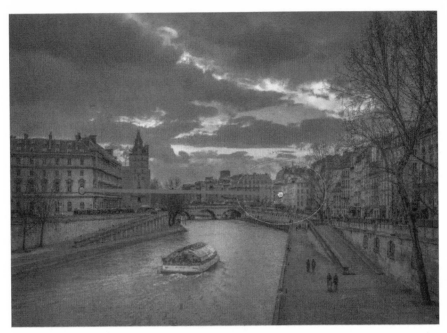

5. Click + Drag the active Edit dot to move our duplicate Radial Filter to a new location

…and we can do this again, duplicating our second to make a third:

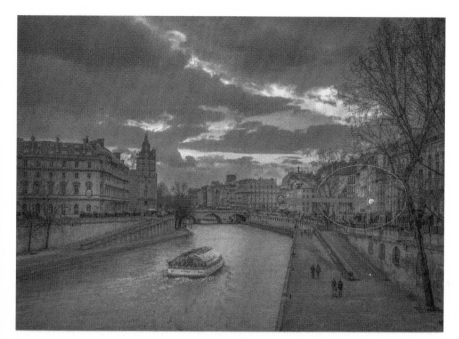

6. Click + Drag the active Edit dot to move the new duplicate Radial Filter to a third location

All I'm trying to do is what I call breaking the Gradient. You see, an object which is partially lit is going to be more interesting and sometimes just adding some of circles of light, performing this dodging, can make your photo a bit more interesting.

It's good to have one in the middle because then you force the eyes of the viewer into the middle of your photo and will give them the impression that your photo has got more depths. Let's look at before our Radial Filters and after:

Left: Before Radial Filter dodging / Right: After Radial Filters are added

Sometimes you may feel that the dodging looks a little obvious. Here's a great technique to refine your dodging to a very organic touch: What you can do is put your attention on something else for 20 minutes or so. Then come back to the photo, and if you can tell right away where the dodges you've placed are, it may be over the top. If you show it to a person and they indicate that there's an off look to it, then you know you've done too much. In these cases, you can re-select the individual Edit dots to lower the exposure selectively in them. Voila, I think we've salvaged this photo thanks to the HDR. Let's have a look at the before and after:

Left: Original normal exposure / Right: Retouched—thanks HDR!

Chapter 13:
HDR Using a Single Raw File

Now I want to show you a little cool trick that you can do with Photomatix: you can do HDR using only one photo. So don't worry if you haven't got multiple exposures—there's still plenty we can do in Lightroom and Photomatix to embellish and make a single shot really pop.

Our single raw file, a photo taken in Florida.

Lightroom Preparation

We'll start, as usual, adjusting the colors, Lens Correction, & sharpening in Lightroom. I don't like the colors. Let's begin on the Basic panel, and try out a few White Balance Profile presets. I have a look at Daylight, but decide that Shade would be better.

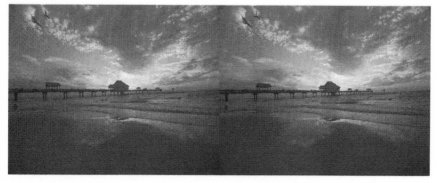

Left: Raw file as shot, no color correction / Right: Shade Preset—much better, warmer sunset

Now we'll head down to the Lens Correction panel and implement our standard three steps: Check *Enable Profile Correction*, check *Remove Chromatic Aberrations*, and click *Auto*. We don't see any keystone correction from Auto with this photo, possibly due to the lack of vertical lines. But there's a pretty severe angle to the horizon that I'd like to address. Let's head to the Crop Overlay tool.

STRAIGHTENING

The Straighten tool on the Crop Overlay panel is going to help us straighten out this photo. I want to make sure it's really straight. To reach it, click the Crop Overlay button in the Tool strip:

1. Click the Crop Overlay button in the Tool strip

From the Crop Overlay panel, click on the Straighten tool:

2. Select the Straighten tool (it looks like a level)

Now we draw a line in the image to establish the desired level angle; this tells Lightroom what we want as our horizontal level:

3. Click and drag in your image to draw the level angle; in this case, I choose the ocean horizon

Release your cursor to see how Lightroom has implemented the straighten adjustment:

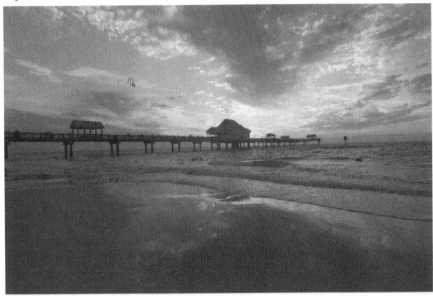

4. Release your mouse cursor to see a preview of the straighten adjustment

Unfortunately, looking to the top left there, we've lost some of the bird. That's not nice. The birds really make the photo. I play with the Crop Overlay tool a bit, but it becomes more apparent that the birds directly compete with the level angle of the photo. Let's come back to try addressing this a bit later. For now, here's what we're working with:

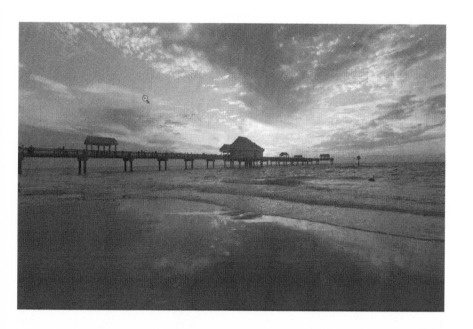

ADDITIONAL COLOR CORRECTION: GRADUATED FILTER

Even with our earlier color work, I think we haven't got enough blues. Let's use a Graduated Filter to see what we can do about that. Click the Graduated Filter button in the Tool strip:

1. Click the Graduated Filter button in the Tool strip

...click + drag on your image to create the graduated filter:

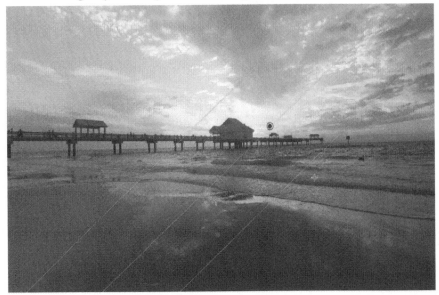

2. Click + Drag to create the filter. Your initial click determines its starting point, and dragging lengthens the filter to reduce its sharpness

Now we want to change the *Effect* of this filter. Click to the right of Effect at the top of the Graduated Filter panel, then select Temp from the context menu:

3. Change the Effect of your filter by selecting from the dropdown

With Temp selected, we can manually adjust our blue by reducing the Temp slider (-33). Now we can readjust the location of our filter by clicking and dragging the Edit dot for it to our desired location further up in the sky:

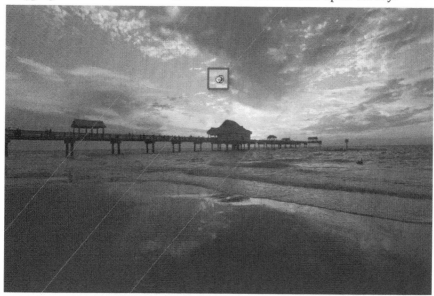

4. Click + drag the Edit dot to adjust the filter's location. You can also drag the individual bars of the filter to stretch/shorten its effect

We've got our blue sky. Now we want to add some contrast to the blue, but it might be too much to simply create an opposing graduated filter at the bottom right. I think there's an elegant solution to this in the Radial Filter.

ADDITIONAL COLOR CORRECTION: RADIAL FILTER

Select the Radial Filter from the Tool strip:

1. Click the Radial Filter button in the Tool strip

Now click + drag on the image in order to create the filter (Note: the radial filter will center on the point of your initial click and expand from there):

2. Click + Drag on your image in order to create and size the filter

As above with the Graduated Filter, we'll select Temp on the Radial Filter panel under *Effect*. This time, though, since we're trying to create a contrast with the blue, we'll now adjust the Tint up to 38. We're also going to scroll down slightly and increase Feather to 100 + check the *Invert Mask* box:

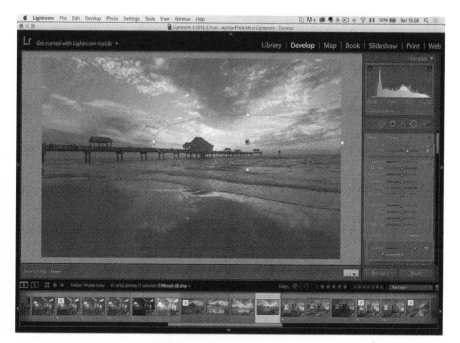

3. Adjust colors on the Radial Filter panel; we also max out Feather &
select Invert Mask below

We've already done a lot with this photo. Let's have a look at what we've done with it using the History pane on the left panel:

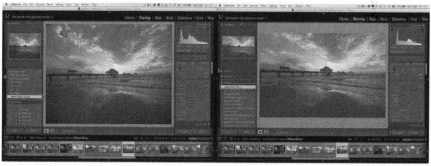

Left: Before / Right: After

You know what, I love the birds, and I've decided that I don't care if the photo is not straight. I think they really make the photo. I'd rather have a little bit of a Dutch angle, so I'm just going to reset our Crop, but take in a little bit at the bottom to make it a little bit more panoramic. And Voila:

If you want to revert all changes made in a tool, use the Reset button on its panel

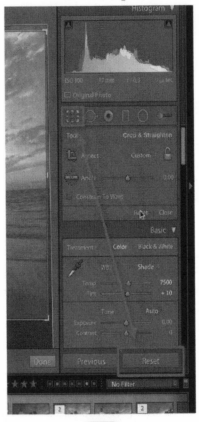

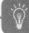

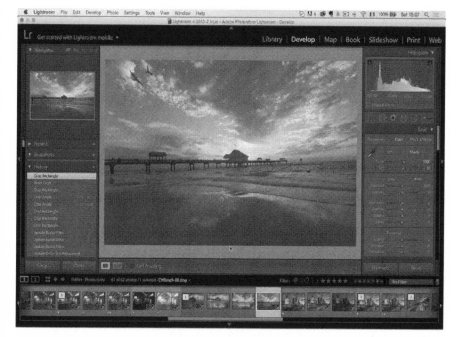

The birds are back in town

The horizon is not straight, but we've got the birds; an acceptable compromise. That's what I want to go for. Now we're ready to jump into Photomatix: right-click the image in the film strip > Export > Photomatix Pro.

Photomatix

Wow. This is already looking great. Let's compare our two go-to Presets:

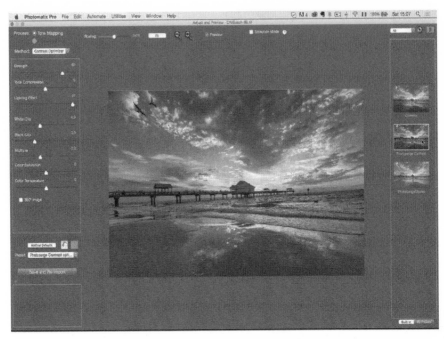

Photoserge Contrast Preset (Contrast Optimizer)

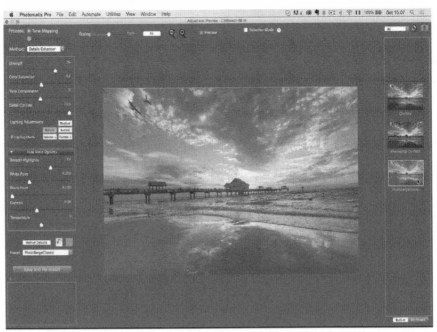

Photoserge Classic Preset (Details Enhancer)

It looks like on this one, Details Enhancer is doing a better job. It's giving us a more vibrant photo. But while the Preset is a great starting point, it's always important to tweak the settings to maximize the advantages of the HDR software.

In this photo, for example, I actually find I prefer the Strength reduced closer to 50. We did such wonderful color work in Lightroom, setting Strength too high may dilute it. I'll boost the Color Saturation a small amount, but leave Tone Mapping untouched in the middle as well as Detail Contrast untouched at 10. For Lighting Adjustment, we check Lighting Effects and decide on Natural over Natural +. I play around with and ultimately decide to adjust Smooth Highlights very high, I really like how it looks. Finally, I'll play with Gamma a bit before settling around 1. Remember, Gamma is going to make things more dense. Let's look at the comparison here, by checking/unchecking the Preview box at the top:

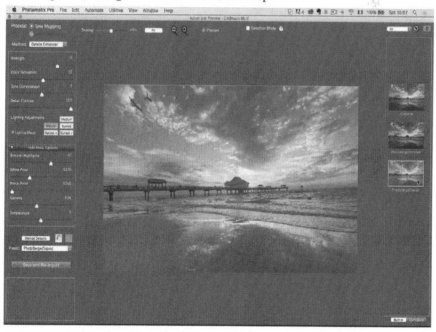

Photoserge Classic Preset (Details Enhancer)

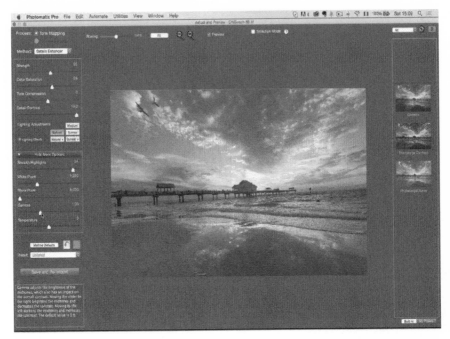

Photoserge Classic Preset + our manual tweaks

Okay, I like what we've gotten out of Photomatix. I'm ready to get back into Lightroom for final edits. Click Save and Re-import.

Lightroom

Back in Lightroom, we can compare our original photo with the re-imported HDR by selecting both and pressing **C** on our keyboard. **Shift + Tab** for full screen. Conceal the side panels with the small Hide/Reveal arrows, and let's zoom in on some details:

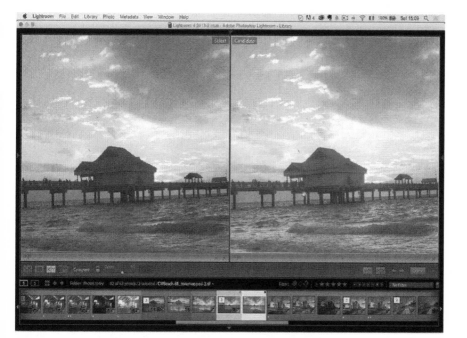

Left: Original photo / Right: HDR

This turned out to be a great example of getting an HDR look on one photo. You can see that the HDR has got more details, a nice feeling to it. It's a bit more intense, more saturated. There's much more detail in the sky, and warmer. We've brought out more detail in the water. It's subtle, but it just makes the photo pop a little bit more.

Let's continue now, to doing a double development on the colors. We'll open up the Shadows (+80) and reduce the Highlights (-60). Holding the **Alt** key to show the mask, I'll minorly adjust the Whites (+30) and Blacks (-15). We've got a nice sunset photo. It's really poppy, which a lot of people find very popular. On the final HDR, I think I would just add a bit of Post-Crop Vignetting down on the Effects panel (-16).

Here's our final product:

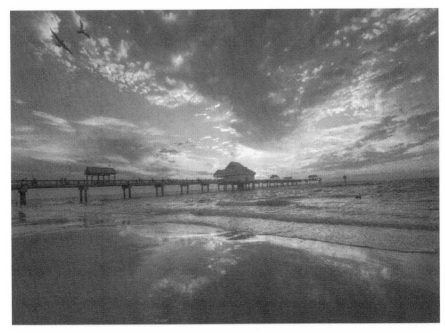

It's not the same angle and it's denser. It's more poppy in a way. It's kinda cool. It can help bring things together. Play around and try to do HDR with just one raw file, sometimes you'll be very pleasantly surprised.

Chapter 14:
Eiffel Tower HDR

I wanted to finish this course with one last nice photo from Paris, a nice sunset, where HDR will really bring something to the table. I'm in the Develop module in Lightroom. Let's have a look at our three exposures:

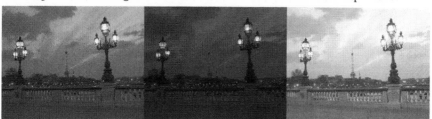

Left: Normal Exposure / Center: Underexposure / Right: Overexposure

Lightroom Preparation

As usual, let's begin with a look at the colors on the Basic panel. We'll check out a few of the White Balance offerings, Cloudy, Shade. I'm going to go with Daylight on this one. I like the blue in the sky against the warmth of the Eiffel Tower and the warmth of the lamps. I think it works really well. Let's move on to the Detail panel.

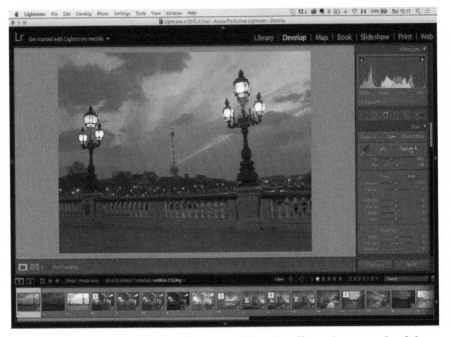

White Balance > Daylight. The blue of the sky offsets the warmth of the lights very well

Zooming in on the sky, the photo looks a bit noisy. It was shot with 100 ISO, but it was shot with a Canon camera, it's a bit noisier than my Sony. I'm going to apply a simple formula for noise reduction here: Sharpening + Noise Reduction should = 100. This was shot with an old DSLR, a bit of a noisier camera, and I've found that formula works well with it. I adjust the Sharpening > Amount slider to around 80, and the Noise Reduction > Luminance slider to around 20. 80 + 20 = 100. I'll also hold **Alt** and adjust the Masking slider under Sharpening a bit (to around 35) to ensure that the sharpening is not applied to black objects.

Use Masking to better determine what will be sharpened in your photo

On the Camera Calibration panel, let's see what the Camera Landscape profile will give us:

Left: Adobe Standard / Right: Camera Landscape

Not bad. I'm going to go with Camera Landscape; it made the whole thing a little bit brighter. We'll also perform our standard three steps on the Lens Corrections panel: check *Enable Profile Corrections*, check *Remove Chromatic Aberration*, and click *Auto*. Not bad. I like what Auto is doing.

Now I'm going to select all three photos in the film strip, click *Sync... >*
Synchronize. Don't forget that after synchronizing, I boost the Noise
Reduction even further for the underexposure (to about 30, on this one). Now
I'm ready to select all three, **right-click > Export > Photomatix Pro**. If,
from previous projects you've still got deghosting options checked, now
would be the time to uncheck it. There's no ghost effect on this one, so I'm
simply going to export. One last look before we head to Photomatix:

I like the sky but I think the HDR program is going to make it even nicer.
Originally I wasn't going to use this photo. When I added HDR, though, it
actually ended up in a gallery because the HDR just brought out that little
extra pop that a lot of people like. A lot of photographers don't, but a lot of
known photographers love it. That's who we're working for.

Photomatix

We're in Photomatix with our imported exposures. Let's see what our Presets
give us:

Left: Photoserge Classic: (Details Enhancer) / Right: Photoserge Contrast (Contrast Optimizer)

I think I'm going to go for Contrast Optimizer on this one. As usual, let's go through both options, though.

Selecting Photoserge Classic (Details Enhancer), I'll click on *Method Defaults* to reset and begin playing around. Remember, Strength we'll set around 80, and Detail Contrast all the way to 100. On Lighting Adjustments, we'll check Lighting Effects Mode, then select Natural +. Natural makes the foreground very bright and I don't like that because the wall is a bit ugly;

there's nothing special to it. Natural + gives us a darker foreground, I think it's nicer. I'm going to adjust Smooth Highlights very high, around 90.

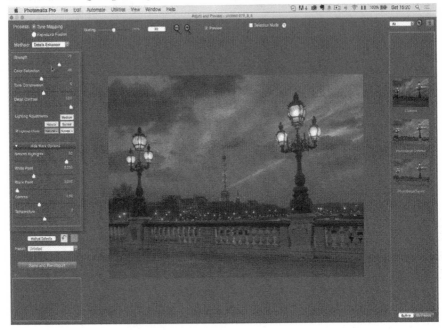

Details Enhancer + our manual tweaks

Voilà. It's not very noisy, it's cool. That's the best of Tone Mapping > Details Enhancer.

Let's jump over to Contrast Optimizer, and again use Method Defaults to reset the options. We'll boost the Strength somewhat, not too much (70). Lighting Effect we'll adjust all of the way to the right (10). Again, my approach is to maximize Lighting Effect while reducing Midtone (-3) to create contrast. Let's see if that's going to give me something nice. That's not bad. Let's compare now:

*Top: Details Enhancer + our manual tweaks / Bottom: Contrast Optimizer
+ our manual tweaks*

I think Contrast Optimizer is definitely winning again. It's just got a nicer look to it for this photo. I think we've gotten everything out of the settings we adjusted, so I'm ready to *Save and Re-import*.

Lightroom

Back in Lightroom, we're ready to do our final adjustments. Let's take a quick look first at our original normal exposure versus our current HDR:

Left: Normal Exposure / Right: HDR

The HDR one has got much more detail. It's more magical, especially in the sky. Look how crisp it is, lacking in noise. Photomatix did an excellent job there. We have a lot more details here. I love it. Photomatix has really gotten better over the years.

We're ready for a little double development. On the Basic panel, I'll reduce the Highlights (-34) while punching up the Shadows (+37). I'll also slightly adjust the Whites (+22) and Blacks (-20). Not so bad.

Double development done, but our foreground is a problem. It's too bright.

We've got a couple of problems to address: the brightness of our foreground, and the slant of the lamps. We'll take these one at a time, starting with the crooked lamps.

We're going to address the lamps a little bit differently this time, not using the Crop Overlay tool. Instead, we'll head down to the Lens Corrections panel, and click *Manual*:

In the Lens Corrections panel, click Manual

Then we use a mixture of the Vertical and Rotate sliders to straighten out our lamps:

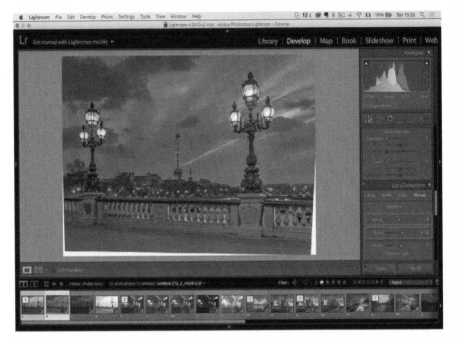

Adjust the Vertical/Rotate sliders to straighten out stubborn crookedness

We rotate and adjust vertical until both lamps point the way we want. Then we can either use the *Constrain Crop* option, or use the Crop Overlay tool to manually crop. I'll re-frame it myself just a little bit to make it more interesting (and conveniently remove some of the foreground pathway we don't want).

Manually cropped. Looking good, lamp!

Our foreground is still way too bright though, it's distracting. Let's add a little bit of gradient using the Graduated Filter tool. Select the Graduated Filter from the Tool strip, then click + drag up a filter over our walkway:

1. With the Graduated Filter tool, click + drag to describe your desired filter area

Now I confirm that our *Effect* is set to Exposure, so that every other slider is zeroed out. We can then safely lower our Exposure to see some nice darkening in our foreground. I don't want so much attention on the floor there. For me, the star of the photo is the two lamps and the Eiffel Tower in the back.

2. Reduce the Exposure to darken the filter area

I'll maybe do a little gradient on the top also, just a little bit. Even better:

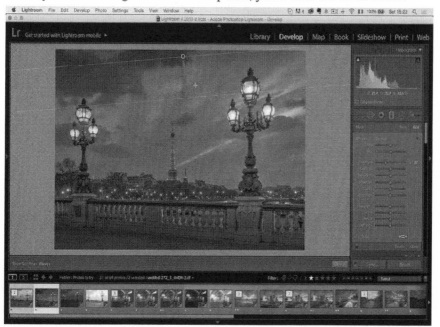

3. Add another, smaller filter to the top to frame the photo

Yeah, I think it's not so bad. As a final step, we'll add some light to the buildings and sky using the Adjustment Brush. Making sure that our Brush Flow and Density are both around 80, we can start with the buildings. I'll reduce Flow and Density ever so slightly, to around 75 for the sky. It works well with the HDR, just to make the photo pop a little bit.

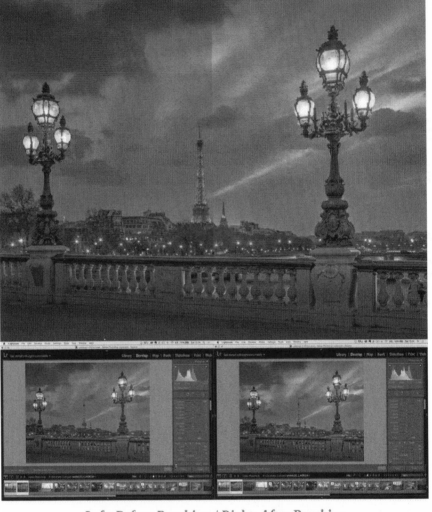

Left: Before Brushing / Right: After Brushing

I think this photo needs a little bit of Contrast (+22) and we're good to go. The photo is so clean, no noticeable noise.

Noise-Be-Gone!

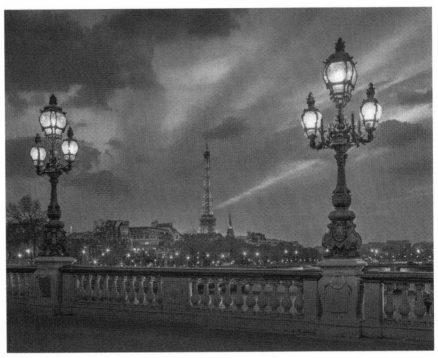

Don't get me wrong: some of these photos can look fake. They can end up evocative of illustration, but in a pleasant way. Believe me, people love this type of photography. I've been selling these with galleries, making books with clients. They love this look; it's very, very popular. The raw files have gotten better over the years, Photomatix has been getting better over the years, we've arrived at a point where you can process HDR and make a nice print, whereas before it was just too noisy. It wasn't good enough. Voilà, Photomatix version 5 came along and really helped it. I hope you've enjoyed this book. I'll see you in another (or one of my online lessons).